THE LIBRARY OF AMERICAN ART

MARSDEN HARTLEY

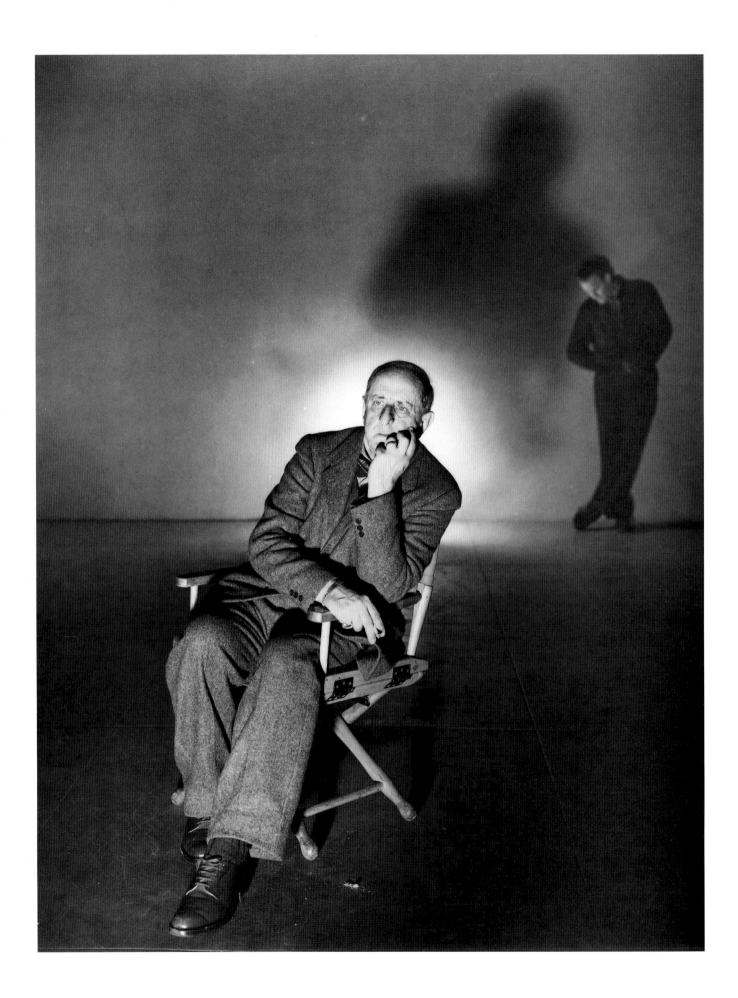

MARSDEN HARTLEY

BRUCE ROBERTSON

Harry N. Abrams, Inc., Publishers
IN ASSOCIATION WITH
The National Museum of American Art, Smithsonian Institution

Series Director: Margaret L. Kaplan
Editor: Phyllis Freeman
Designer: Ellen Nygaard Ford
Photo Research: Colin Scott

Library of Congress Cataloging-in-Publication Data

Robertson, Bruce, 1955–
 Marsden Hartley / by Bruce Robertson.
 p. cm. — (Library of American art)
 Includes bibliographical references and index.
 ISBN 0–8109–3416–7
 1. Hartley, Marsden, 1877–1943. 2. Painters—United States—Biography.
 I. Title. II. Series: Library of American art (Harry N. Abrams, Inc.)
ND237.H3435R63 1994
759.13—dc20 93–46820

Frontispiece: Marsden Hartley, February 4, 1943.
 Photograph by George Platt Lynes.
 George Platt Lynes papers, Archives of American Art,
 Smithsonian Institution, Washington, D.C.

Printed and bound in Japan

Contents

Acknowledgments

My work would not have been possible without the pioneering work of Elizabeth McCausland, the generosity of Norma Berger, and the scholarship of Barbara Haskell, Gail Levin, Townsend Ludington, and Gail Scott.

I have been profoundly fortunate in my research with the generous response of the staff of the collections and libraries I visited, including: the Archives of American Art, in Washington, New York, and San Marino (especially Barbara Bishop); John Driscoll and Kathryn Mannix, Babcock Galleries; Genetta McClean, Director, Museum of Art, Olin Arts Center, Bates College; The Beinecke Rare Book and Manuscript Library, Yale University; Ann Abid, The Cleveland Museum of Art; Ida Balboul and Kate Derosier, The Metropolitan Museum of Art; Lyn Korenic and staff, Art Library, University of California, Santa Barbara; Robin Jaffee Frank and Helen Cooper, Yale University Art Gallery. Friends have helped immeasurably: Jeff Cunard, Robert Dance, Myra Orth, Martha and Ken Severance, Nissa Simon. Also, I have been fortunate in the support and advice of my colleagues in Cleveland and Santa Barbara: Mark Cole, Ellen Landau, William Robinson, Evan Turner; and Henri Dorra, Abigail Solomon-Godeau, Robert Williams, Fikret Yegul. My research was supported in part with a Regents' Junior Fellowship from the University of California. Jonathan Weinberg's excellent *Speaking for Vice* was published after this text was completed, and has not been consulted.

This book came about through the suggestion and advice of Ellen Landau and Phyllis Freeman: I hope they like it.

BRUCE ROBERTSON

Introduction

I always offer two signs for recognition: a vast nose and ultra blue
eyes—the rest is nothing much.—Marsden Hartley, 1938[1]

MARSDEN HARTLEY IS THAT RARE FIGURE in American public life, an artist with a second act. Within five years of his first New York exhibition he was on the threshold of an important international career as one of the few Americans painting original abstractions just as abstraction itself was being developed. Then World War One demolished his plans. Thirty years later, as the United States entered World War Two, Hartley rediscovered his voice, one with the power to speak to later generations. At his death in 1943, he was painting as strongly as he had in his youth and was considered one of the most important American painters of his generation, a reputation which has grown stronger and more complex with every new generation of artists and audiences.

During the long years between the wars, Hartley seemed to try out different subjects and styles in a desperate attempt to find something that worked and would sell. Periodically he would travel to new places, try on new fashions, convert to a new philosophy, all to no avail. But this shifting and haphazard search concealed a steadfastness of purpose and meaning which remained consistent throughout his career. Hartley always took himself as a New Englander, granite-like in his probity and his sense of himself and art; no matter what the circumstances or to what degree Hartley might merge himself into some foreign or voluptuous environment, he remained unyielding and reserved, never giving himself fully over. In this he stands in that long line of New England travelers and visionaries who, no matter where they voyaged or what they saw or how much they might be swept up, always ultimately knew they came from Boston. Hartley's sense of himself as an American, and one from Maine at that, lay at the root of much of his work, both his best and his worst.

Hartley thought of himself as an essayist and poet as well as a painter, and for long periods would spend as much time writing as painting. He was proud of the four books he published during his lifetime, and left the manuscripts for many more at his death. But in his writing he speaks to us in the New England voice of the perennially disengaged and prudish, obliquely, and with a certain surface beauty and no great heart. His writing, for all his command of modernist syntax, looks backward to his New England past more than forward into the twentieth century. His painting, however, is savagely direct. The aesthete, the urbane traveler, the pompous prig, the arch cosmopolite, the maudlin queen—the roles Hartley played to his contemporaries—reside in his words. His paintings cast aside this dross; they are the work of a vivid, agonized, and simple man. It is the task of this book to convey his complexity, but leave the reader with the Hartley worth knowing.

Hartley wrote in his autobiography: "I was meant to be a spectator and so I have done my best to make an art of observation." He spoke often of his eyes: "If one is slow in tongues one's major contact is by silence—so I find life rather a religion of the eyes."[2] This stress on looking is only natural for a painter, but for Hartley it had a particular urgency: he looked *because* he could not participate, could not touch. As a gay man, Hartley felt that all ordinary expressions of love were forbidden him, especially the life of the home, of domesticity. His private life—his affective life—had to be divided sharply from his public life. But Hartley felt equally strongly that his art expressed his own experience. In 1914, in his first public artistic statement, he wrote: "A picture is but a given space where things of moment which happen to the painter occur. . . . The present exhibition is the work of one who sees—who believes in what is seen—and to whom every picture is a portrait of that something seen."

The strain of both hiding and revealing his secret self, and the stratagems he used, lie at the heart of his art and are the source of his power. Hartley, in a sense, touches with his eyes. His paintings gain their striking density and material presence in a displacement of his desperate need for physical affirmation. Hartley embedded his art in the then-fashionable ideas of empathy and mysticism; both had to do with apprehending the physical world through immaterial means: "Eyes speak:/THING of things, let us go on living/seeing everything forever, all the time/seeing." But both beliefs served him as sublimations.[3]

Living a life which consisted largely of wishes and self-denial, Hartley was not a restful person. As the writer Chenoweth Hall recalled: "I was always touched by the terrible loneliness and by the manoeuvres to disguise it even from himself—and the scorching kind of ambition that ate at him all the time."[4] Pointing to the degree his personality shaped every aspect of him, Robert McAlmon, the writer and publisher with whom Hartley shared some of his sexual escapades in Berlin and to whom he wrote some of his frankest letters, declared: "I myself could not disconnect him from his personality, bitterness, infatuated and mainly frustrated passions, his vitriolic hatred of what didn't happen, and his utter gaiety and wit when he was around with people he liked who had a sense of wit. Never knew anyone who knew the extremes—grim tragic gloom to utter hopefulness and joyous gaiety, when he thought he was being liked or loved."[5]

Despite the profusion of his autobiographical writings, Hartley knew himself most certainly in his painting. One late self-portrait is particularly revealing. In *The Sustained Comedy (Portrait of an Object)* (1939), he presents himself as a sailor with tattoos and an earring. Over his heart is a crucified man and a sailing ship—a reference to the sacrificial drowning of Alty Mason, a young man he had passionately adored. On either shoulder are signs of nature and on his face, a clown's makeup. His eyes have been pierced by arrows (a little large for Cupid's and in the wrong place for Saint Sebastian's): Hartley is a victim of love and God. But out of a mystic triangle on his forehead (his visionary eye) darts a thunderbolt, while another hits the heart in his throat, signs of the power of his mind and unspoken heart. This bizarre image reveals, beneath the world of

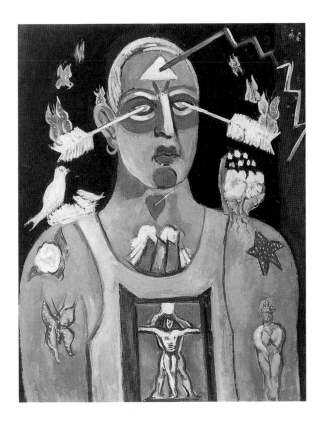

*The Sustained Comedy
(Portrait of an Object)*

1939. Oil on board, 28⅛ x 22 ″
The Carnegie Museum of Art, Pittsburgh.
Gift of Mervin Jules in memory of Hudson Walker

*This symbolic self-portrait recapitulates
many motifs Hartley painted during
his whole career, both abstract visionary
signs of arrows and triangles, and the
butterflies and flowers he had collected
since childhood.*

things that Hartley obsessed over and painted all his life, his own face. Hartley
denied this connection between his feelings and his art repeatedly after the
death in World War One of his first great love, Karl von Freyburg. In 1928 he
claimed: "I prefer to have no personal life. Personal art is for me a matter of spir-
itual indelicacy."[6] But as *The Sustained Comedy (Portrait of an Object)* discloses,
despite the savage self-mockery of the title, Hartley's art reveals himself.

As a man, Hartley spent his life on the outside, looking with longing and
anger at an ordinary world he was shut out of. This alienation was compound-
ed by his personal history: his mother died when he was eight, and for the rest
of his life his many attempts at reconstructing a family and home failed. As an
artist, however, his homosexuality gave him a place of strength beyond the
accepted and unanalyzed norms of life where he could observe at a distance
and re-create them in his painting. Pushed to the margin, gays and lesbians have
been made that much more powerful in their reimaging of the center, as has
been true for other disenfranchised communities in America. Playing with,
reshaping, and critiquing the culture of the center, they have held up a mirror
to mainstream society with a more interesting face in the mirror than may actu-
ally stand in front of it.

Despite Hartley's disappointments in a career without much recognition or
even food (he not infrequently cadged food from friends or half starved), he
told his niece Norma Berger at the end of his life: "I am not a 'book of the
month' artist and do not paint pretty pictures; but when I am no longer here my
name will register forever in the history of American art and so that's something
too. But O the difficulties—all monetary of course because the rest is pure sat-
isfaction—joy—and a feeling of having gone where one was heading for."

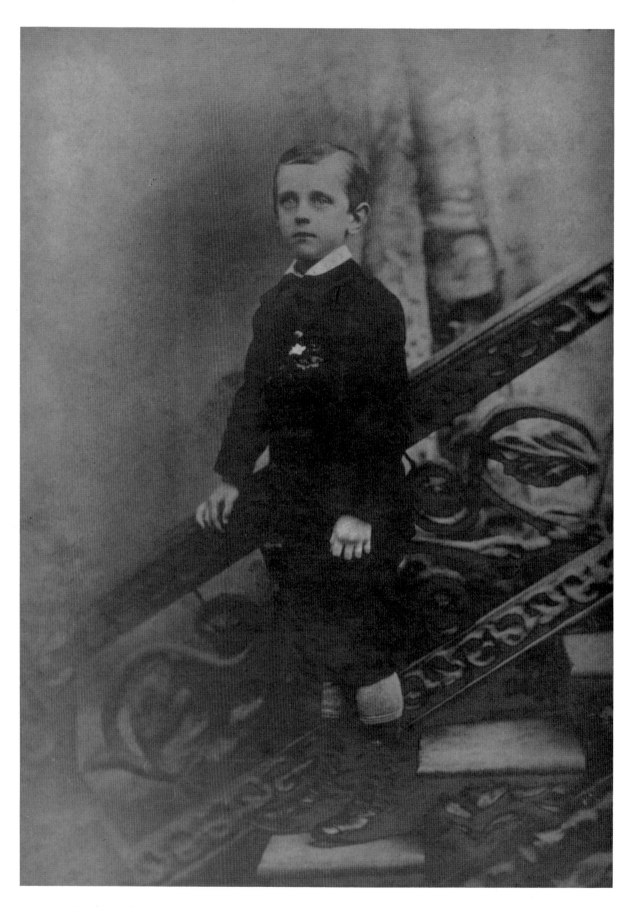

Edmund [Marsden] Hartley, age eight, 1885

I. Becoming an Artist and a Man

WRITING FROM BERLIN IN 1913 AND ENJOYING the sense that he had found a true spiritual home at last, Marsden Hartley described his past to his patron and friend Gertrude Stein: "I am without prescribed culture and I have grown up out of a strange thicket, and have, I am certain, survived those two elements which I have always considered fatal—heredity and environment. I have mastered them both in that I have ignored them." In truth, however, the circumstances of his birth and childhood determined the shape of much of his life. Writing his memoirs many years later, he pondered a photograph taken of himself at the age of eight, Edmund Hartley (as he was christened) dressed up in a smart new suit with a flower in his buttonhole, gravely regarding the camera: "I look at this little lad and say: 'Why did you want to do all that I have had to do to be you—how did it start after all?'"

Lewiston, Maine, where Edmund Hartley was born on January 4, 1877, is a small industrial town with a built-in inferiority complex. Lewiston is really half a town, lying on the east bank of the Androscoggin River, while Auburn lies on the other, connected by a bridge or two but divided by government, economy, and class. In the late nineteenth century, the cotton mills where Hartley's father worked were located in Lewiston, along with most of the workers' housing, while in Auburn shoes were made and the factory owners lived. Auburn, as the name suggests, hearkened back to the suburbs of Boston, while Lewiston's name recalls the French Canadians who comprised the largest minority in the town. This bifurcated history might be taken as an image of the divided nature of Hartley's own life and heart, always neither one thing nor the other.

Thomas Hartley and Eliza Jane Horbury, Hartley's parents, had emigrated before the Civil War from Manchester, England, a great cotton mill center, to work in the same industry in America. This change in location, while it brought no advancement, did bring a measure of security and happiness. Despite Thomas's general impracticality—he once tried raising horses and another time adopted three bear cubs—the Hartleys reared a family of eight children in adequate comfort. Like most Victorian families, however, they were shadowed by death: one daughter and two of the three boys died young, leaving Edmund, the youngest child and last son, to grow up with his older sisters.

Hartley's first years were filled with nature and color. Lewiston today bears the scars of several depressions and years of failure, with only a light veneer of recovery and rehabilitation. But in Hartley's youth, the town was thriving, the ugly red-brick factories half-hidden by the flowering chestnuts which lined the

Edmund [Marsden] Hartley,
age eight, 1885

Anonymous photograph.
Bates College, Museum of Art, Olin Arts Center,
Lewiston, Maine. Marsden Hartley Memorial
Collection

When Hartley was eight, two tragedies struck. The death of his white kitten seemed symbolically linked to the death of his mother. This photograph, taken just before, always seemed to him to be a talisman of the happiness he had lost.

canals, and fields and woods only a short distance away. In his memory, while the sound of the mills was strong, the sound of the falls of the Androscoggin was stronger; he remembered most the park near his house where he picked violets and other spring flowers, or treasured colorful stones or pieces of glass: "Things in themselves engrossed me more than the problem of experience. I was satisfied with the effect of things upon my senses, and cared nothing for their deeper values."[1]

After 1885, this intimate world of little pleasures disintegrated: Eliza Jane Hartley died, and the family broke apart. "I was to know complete isolation from that moment onward," he recalled. Two of his sisters left for Cleveland, Ohio, to join a third already there and married, while Edmund remained with his father and oldest sister, Elizabeth Ann, who was married and living in Auburn. After a few years' shifting for himself, his father voyaged to England, to claim a new bride, Martha Marsden, taking Edmund with him. On Thomas Hartley's return, however, he and his wife moved to Cleveland to join his daughters, leaving Edmund behind with Elizabeth Ann. It was not until 1893, four years later, that Hartley rejoined his father, stepmother, and sisters in Cleveland.

The shock of his mother's death and the breakup of his family forced Hartley to retreat into an imaginative life of his making. Later, he could really only recall his sister Elizabeth from this period, and very little from before. He was timid and weak, and later confessed to his niece: "I only wish I were a great husky brute—a prize fighter or something as I would love to be powerful and excel in bodily strength. It makes me terribly envious when I see men swimming or running or boxing—and I want to get right into it all and be the real thing." Instead, he walked to his red-brick schoolhouse, and went next door to the granite Episcopalian church, where he sang alto in the choir, and wandered in the fields.

This isolation fed his artistic impulses, which were largely restricted to coloring in pictures from magazines. His tastes were sentimental at best: one surviving illustration, *Love's Messenger*, which shows a woman draped in white beneath a flowering apple tree with doves around her, is typical.[2] As for his family, he felt both shut out and angry, as well as different. His father was conventional and a dreamer, held upright through life only with the help of his wives. The death of his first wife left Thomas Hartley unable to cope with much (it was perhaps at this time that he gave up his job in the mills to work for his late wife's nephew putting up theater posters, often leaving his son alone for long periods). Hartley was always grateful for his stepmother's vivacity, which brought laughter to his father, and eventually he adopted her name. But his father's inability to care for him after his mother's death, and his parents' incomprehension of his goals always nagged at him: they thought he ignored them because he never sent them back money, the practical sign of love and filial duty. But life wasn't entirely bleak. Hartley's lifelong love of circuses, pageants and parades, opera and vaudeville was formed in Lewiston, where he had easy access to his cousin's theater.

In 1892, the year before he rejoined his parents, Hartley at the age of fifteen

BECOMING AN ARTIST AND A MAN

Uncle Ed [Marsden Hartley] and nephew, c. 1900

Anonymous photograph.
Bates College, Museum of Art, Olin Arts Center, Lewiston, Maine. Marsden Hartley Memorial Collection

Hartley's family, despite its breakup and his infrequent visits, remained important to him all his life.

had already left school and had begun working in the office of an Auburn shoe factory. Arriving in Cleveland, he found himself a job in the office of a marble quarry and importing business. Moving to one of the fastest growing cities in the nation, as he wrote later, "did in reality separate me from being the derelict upon that shore, as who knows if I would ever have come out from the darkness there with the extreme shyness and diffidence that possessed me as a boy [in Lewiston]."[3]

Lewiston and Auburn were small towns, hours from the nearest large metropolis, Portland. Cleveland, however, was booming, a town that was fortunately situated on the Great Lakes to benefit from the flow of raw materials from both Ohio and the far Midwest. Although no museums or orchestras were yet established, the wealth of Cleveland was busy improving itself and the city. While the Rockefellers had gone, leaving as a record of their wealth only a Baptist Church and a couple of fine houses on Euclid Avenue, one of the most opulent streets of mansions in America, many other millionaires remained. The only collection of early Italian Primitive paintings outside the East Coast sat in a gallery by Lake Erie in the eastern suburbs, and other cultural enterprises were beginning to stir. Much of the artistic life was dominated by German immi-

grants, as it was throughout Ohio and the Midwest, and this was to have a lasting effect on Hartley.

Hartley soon lost his office job because he took time off for painting lessons from a local artist, John Semon, who specialized in dimly golden Barbizon landscapes. Hartley recalled: "Semon planted the art virus in my soul." But his impractical persistence won him a scholarship at the local art school (now the Cleveland Institute of Art). Two teachers there proved enormously influential. The first was Nina Waldeck, his "first German," as Hartley later wrote, his "lucky star in art."[4] Her most important contribution was to give him a book of essays by Ralph Waldo Emerson, confirming for him the validity and purity of his sensations of the natural world as the foundation for his work. Emerson's words in "Self-Reliance" and "Compensation" resonated with Hartley throughout his life: "He cannot be happy and strong until he too lives with nature in the present, above time. . . . God reappears with all his parts in every moss and cobweb. . . . Thus the universe is alive. All things are moral."

The second influential teacher was his summer school instructor, Cullen Yates, a nationally known artist who painted willowy young women perched sweetly on foggy hillsides. Yates took the initiative to convince a trustee of the school, Anna Walworth, to give Hartley a stipend to study in either New York or Cincinnati for four years. Hartley chose New York.

And in choosing New York—at the age of twenty-two with almost no formal education—Hartley headed for the most exciting art school, William Merritt Chase's. He did not stay long—the fees were too high—but Chase left an indelible impression during the Saturday critiques, when he would appear elegantly dressed and adorned, with his beautiful hands enhanced by fine rings. Hartley recalled that Chase taught him that "fine performance is the major part of good painting" (which was not limited to the dash of putting paint on canvas), and also lectured on "the majestic privilege of being an artist." Both attitudes were to cause Hartley trouble later, as he used elegance and attitude as an armor to protect his shyness and insecurity. And Hartley could never resist the glitter of beautiful jewelry, even during periods of poverty; still today the collection of his personal effects at Bates College is awash with rings, silver cigarette boxes, and other magpie trinkets.[5]

Within a few months, however, Hartley transferred to the more conservative but cheaper National Academy and remained there for the next three years, learning an acceptably diluted aestheticism. It would be years before he left his teaching behind.

New York was also the place where he began to find himself as a person, with the same hesitation and delay that marked his becoming an artist. In fact, the artist and the man were intimately intertwined and had been from the beginning. Hartley remembered that "I began somehow to have curiosity about art at the time when sex consciousness is fully developed and as I did not incline to concrete escapades, I of course inclined to abstract ones and the collection of objects which is a sex expression took the upper hand." This passage in his autobiography lets slip a number of interesting points of connection between his art-

Marsden Hartley, c. 1905–10

Anonymous photograph.
Yale Collection of American Literature,
Beinecke Rare Book and Manuscript Library,
Yale University, New Haven, Connecticut

*Hartley displayed his self-conscious aes-
thetic moodiness from an early age, an
armor he used to hide his loneliness and
insecurity. Note the ring on his little fin-
ger, one of the many pieces of jewelry he
acquired throughout his life.*

making and his life. The most telling is his matter-of-fact acknowledgment that
"concrete escapades" were beyond him: Hartley was, in fact, gay. Uncertain and
unclear at first about the nature of his sexuality, stifled in its expression, he sub-
limated his love of beauty and the tactile sensuality of flesh into art—specifical-
ly into collecting objects. The erotic character of "objects," the fetishistic power
of things rare or beautiful or common, became one of the important well-
springs of his painting. Collecting pottery (he kept until his death teapots and
vases he had bought in Cleveland from local potters as a youth) and jewelry was
perhaps the first expression, but painting things was the most significant. Equal-
ly important was his choice of the word "abstract" to describe this sublimated
and repressed sexual interest in objects. For, of course, it is his abstract paintings
of objects which are some of his most powerful works.

But what did it mean for Hartley to be homosexual in New York as a student
and young man? There was a thriving gay subculture in the city, but Hartley
seems to have been too inhibited and insecure to participate in it. Nonetheless,
he was gregarious by nature; he loved dancing even though he was shy and
unable to engage in "concrete" adventures. And he always managed to sur-
round himself with friends despite not being a real "red-blooded male" who
could play any games or sports, as Richard Tweedy, an early friend, rather sourly
remarked at the end of his life. At the same time, Hartley's sexual orientation
acted as a barrier, cutting him out of any complete sympathetic or unconsidered
sharing. Always he held something back, a pattern which marked his social
interactions for the rest of his life. He would join in, even frenetically, but always
on a conscious, willed level: he never really relaxed and after a short time
became very tiring company. Only, and then very obliquely, could he express his
full self in his art.

From the very start, Hartley's friendships revolved around passionate crushes on men and devotedly platonic relationships with women: he lived in a world of intense, roiling feeling with no tangible outlet for it, other than his transcendental love of art and nature. His innocent letters to his young niece Norma Berger inadvertently reveal his heart (later, when he knew himself better, he would never permit himself such freedom of expression). Writing to her in 1910 when he was thirty-three and she was in her teens, he was charmed that she had a boyfriend and declared: "I know I would like him and maybe he would me for I have a faculty for attracting fellows around me—so they say." Later that summer he told her: "I make it my business to be a friend to all mankind and so my friends are of many kinds—one a sailor and one a barber (in Lewiston Maine) a splendid clean handsome fellow too. . . . I wonder if girls have as good times as boys do when they are together—I wonder if they feel as strongly toward each other as boys do—I hope so—boys are such straightforward frank things—and when they are affectionate as tender as can be to each other." But it is clear that this affection never became more than that. The next summer, visiting his friend John Wilson (the sailor from the year before), he described Wilson writing a letter: "I guess to his sweetheart—though I never ask questions about these intimacies from even my friends." This reticence always prevented him from making full contact with another human being. As he wrote to his niece in 1924: "A friend from 1901 said 'You are so like a page out of the Bible in my life because you have kept yourself so impersonal in friendship—so many people take and usurp and destroy'—Well—I've never wanted anything from anyone but impersonalities." But he always hoped for more and this hopefulness motivated him.

As early as 1904, he imagined a life where physical affection between men might take place, long before he seems to have experienced it for himself. Jocularly and wistfully, he placed it in Europe: "My love and kisses too if you want to your Papa though I suppose kisses to a man don't sound right but you know in some countries, like Italy and France, brothers and friends and fathers and sons kiss each other with real affection and there is something nice about it for the love of a man for a man is beautiful. I think I love my men friends very dearly." Later he would declare: "I find spiritual marriage in the form of friendship is the big thing for me." But it is clear from the failed friendships of his student days that the intense, and ultimately sexual, relationships that Hartley wanted could not be found in America, let alone Maine. Long before he got to Europe he knew his physical life could only begin there.

Hartley's feelings, still not clearly sexual to him, found validation in Walt Whitman, whose poetry he had been introduced to in 1904 by friends in New York. The importance of Whitman was confirmed by the support of Horace Traubel, Whitman's closest friend and comrade, beginning the next year. Whitman's poetry assured Hartley, as it did many Americans at the turn of the century, that it was possible to find love in the company of men, to "perceive one picking me out by secret and divine signs/. . . Ah lover and perfect equal,/ I meant that you should discover me so by faint indirections." Whitman reaf-

BECOMING AN ARTIST AND A MAN

firmed Emerson's transcendentalism for Hartley and proved that the love of nature could be combined with the love of man. As Whitman declared in one poem: "Spontaneous me, Nature,/The loving day, the mounting sun, the friend I am happy with,/The arm of my friend hanging idly over my shoulder,/The hillside whiten'd with blossoms of the mountain ash."[6] Whitman enabled Hartley to realize that man and nature could coexist at the core of his heart, and thence his art, as he was shortly to discover.

The hope of "secret and divine signs" sustained Hartley, and his letters reveal their constancy and urgency, as well as the fact that he seems not to have acted on them. Visiting his friend Wilson on his ship stationed in Boston harbor, he wrote Norma: "I saw many handsome sailors . . . one very handsome blond fellow with soft blue eyes—he looked at me quite a little—and I felt that he wanted to talk to me—but there seemed to be no occasion—so we just looked and passed on—and I shall always remember his fine manly face. . . . One sailor was playing a waltz . . . and up the deck a little way two sailors were waltzing together. . . . It was all so beautiful to see as I stood close by my friend Wilson." While Hartley would return to this physical ideal again and again in his life (and at the very end in his art as well), at this point his own body and anxieties stood in the way: "I love to look at good looking people—indeed I think it a most sterling virtue, and the duty of the many who are not well blessed with those gifts to overcome it as much as possible if only for those sensitive—aesthetic eyes which see so much that is painful to them. I myself know several persons who are a constant delight to me because of their superb physical beauty and I think it really a privilege to look upon fine bodies and to have intercourse with fine minds." The distinction in his roles between merely "looking" at bodies while having "intercourse" with minds (even if Hartley does not mean the word to have our modern physicality) reveals the barriers he placed between himself and the world of physical experience. "Looking"—the very act of being an artist—assumed a disproportionally important place in Hartley's life. "Looking" was loaded with all the sexual frustrations and burning love Hartley was not yet able to express by any "concrete" means.

Ironically, Whitman's poetry and philosophy would come to bear on Hartley's art not in the metropolis of New York but in quiet Maine, during the year 1906–7. Every summer after school ended, he had returned to Maine, intending to find his voice as a painter there. He declared to Tweedy after the first year of school: "Beauty is my one aim in life. . . . I shall show [my friends] the beauty of Nature as she lives here in Maine." It seems he spent most of his time collecting butterflies and flowers instead. During the summer of 1904, he occupied himself reading Maeterlinck and planning on going to Italy, to put the traditional polish on an artist's education. But in August he found that his grant was not to be renewed and all plans had to be canceled. Stuck in Maine, he began the scramble to survive, one which persisted the rest of his life.

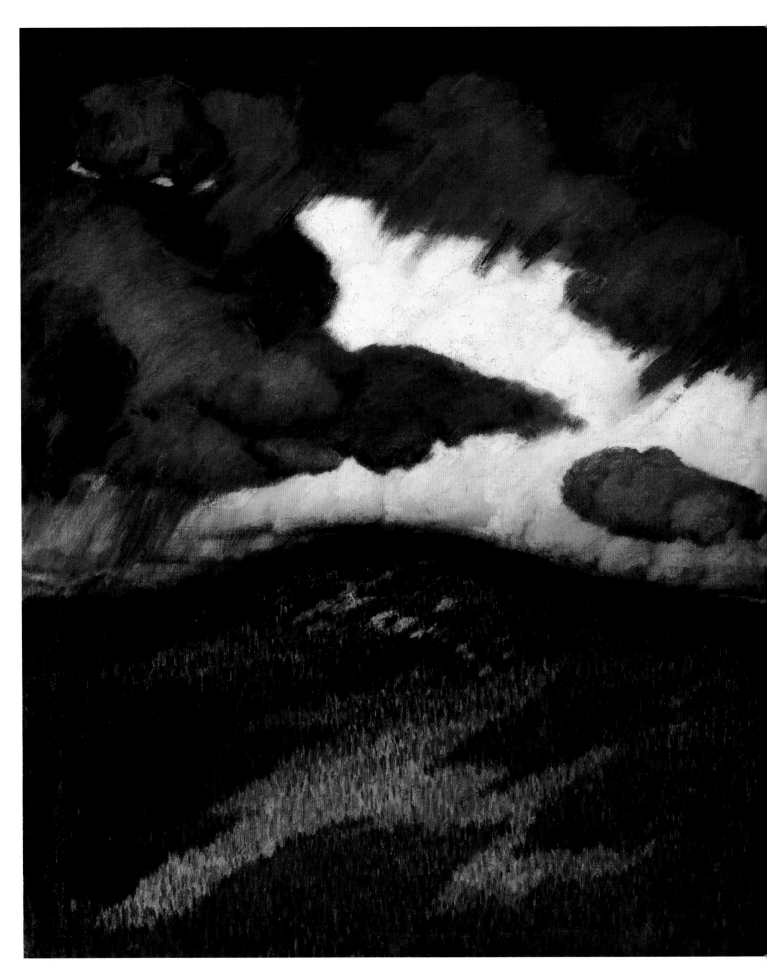

Storm Clouds, Maine

II. Maine and New York, 1906–11

URING 1906, HIS TWENTY-NINTH YEAR, Ed Hartley changed his name at the suggestion of friends in New York, adding his stepmother's maiden name. He made his first appearance as Edmund *Marsden* Hartley in a small announcement he circulated that fall in Lewiston, a notice that he was opening a studio to teach art classes. Although it proved a failure, this professional venture and the name change seemed to force his development as an artist, a process which accelerated even as he decided to drop "Edmund" a few months after his thirtieth birthday.

It is worth considering for a moment the import of this change, which betokened a new stage in his life. The initial motivation must have come from the simple and pretentious desire to have a full and impressive name like everybody else; the decision then to drop his first name heightened the pretension, and announced his new role as an *artist!* Taking his stepmother's name also marked an attempt to move closer to his family, perhaps to forestall the criticism that he was not making a living: by 1900 his parents had returned to Lewiston, and he was now living with them year-round. But for an only son, one who was never to continue family names in any other way (and who may have already sensed the likelihood of this future), the issue of names touched on the matter of heirs. In a sense, bearing his stepmother's name made him a son of both parents; and this new birth, this addition to the Hartley family—a process which is normally biological—was accomplished without the benefit of procreation. The new name simultaneously announced his allegiance to his family, and signaled his distance from normal family roles. "Marsden Hartley," then, refashioned his personal history in a way familiar to many gay artists. Hartley's sense of Walt Whitman as a model for male life, recently developed by his new friendship with Whitman's friend and literary executor Horace Traubel, no doubt confirmed his sense of separateness and independence from family.

Assuming this new identity did not necessarily mark a change in style. For one thing, he continued as he had begun, as a landscape painter. Hartley's efforts as a student had reflected the popular tonalist painting of his day, which was for the most part rather monochromatic, with strong effects of color or emotion avoided and subtlety preferred. Now, most of his attempts were still rather sweet and ordinary; one work he described as a "study of sunset glowing through the pine woods with the first snow on the ground in patches left where the day sun has not reached there much."[1]

Hartley's first really successful painting, *Storm Clouds, Maine* (1906–7), indicated the different path which lay ahead of him. First, it is the mountain, not the

Storm Clouds, Maine

1906–7. Oil on canvas, 30⅛ x 24¹⁵⁄₁₆"
Collection Walker Art Center, Minneapolis.
Gift of the T. B. Walker Art Center,
Hudson Walker Collection, 1954

Hartley's first mature painting, a view of Speckled Mountain near Lovell, Maine, done just after he had changed his name and set up his first studio.

atmosphere or light effect, which has inspired him; he has managed to capture its heaviness and sense of slumbering power. Second, although the colors are not bright, they are dramatically arrayed in distinctive patterns that vitalize the surface of the mountain—a nervous disjunction between surface and depth which Hartley would exploit frequently later. Third, this is no quiet day but a day full of thunderstorms and heavy rain; Hartley has managed to suggest the way in which the mountain is involved in producing and directing these clouds as they climb and compress up one side and down the other. Last, Hartley's emotional reaction dominates the work: for all his protestations of feeling at one with nature, the mountain dwarfs his human presence and reaction. Nature is threatening or indifferent or impenetrable, as Hartley would discover again and again. The mountain is central to his endeavor. Hartley wrote to Horace Traubel, soon after finishing the work: "I loathe being apart either from my crowd or my mountains and just now I am both, except in my pictures. . . . I would be happy if I could show you my later efforts at rendering the God-spirit in the mountains."

The following summer was to expand his awareness of this "God-spirit." Traubel suggested Hartley work as a handyman at Green Acre in Eliot, Maine, a religious community devoted to exploring Eastern religions. Traubel, who had guided Hartley's love of Whitman, now opened up a world of theosophical mysticism to him. The atmosphere of brotherhood, which Hartley always cherished, soon let what little remained of his Episcopalianism melt away. But Hartley was never a devoted follower; he remained at a critical distance from the swami and other Eastern mystics, wishing to fit what he learned into his own needs and desires, as he was to do all his life.

Hartley's tastes as an artist were still essentially coloristic, despite the exhilarating power of forms in *Storm Clouds, Maine*. Now his love of color began to be driven by a sense of exaltation. As he explained to Traubel: "I think nature is never quite so dramatic as when she is bared to the brow and shows her face in sturdy acceptance of the coming cold and dreariness, with the 'cool unfolding' purples and the deep greens that mingle sedately with it, set off here and there with sketches of mauve white or cream grey. . . . It is like a strong resonant octave out of Chopin, out of Grieg. One person lately told me that to her my painting is on the plane of Grieg's music which is a little complimentary, and something to live up to." The two themes sounded in this letter—his interest in wintry, northern effects and the comparison with music—were to motivate much of his later painting.

His next step forward came during this period, when he discovered the work of another mountain painter, Giovanni Segantini, reproduced in an issue of the Munich magazine *Jugend* (page 22). Recollecting Segantini's paintings, he would write that Segantini had discovered "the effects created on the body of the mountain by refractional rays of light"; he was referring to Segantini's cross-stitch stroke and the intensity of his colors. These provided a magic release for Hartley from his education, giving him the authority to build on the power he had first achieved in *Storm Clouds*. Now he could see the hills, instead of gen-

Carnival of Autumn

1908. Oil on canvas, 30¼ x 30⅛"
The Hayden Collection.
Courtesy Museum of Fine Arts, Boston

As the title suggests, Hartley loved the lively colors of autumn, despite his preference for winter, when nature "is bared to the brow . . . a strong resonant octave out of Chopin, out of Grieg."

Carnival of Autumn

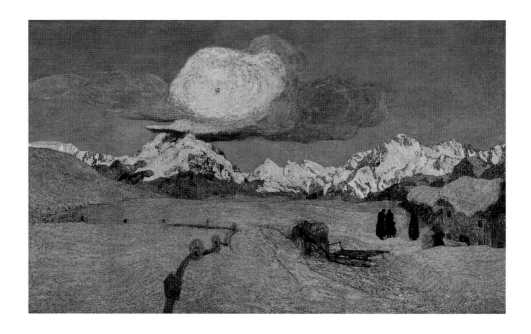

Hartley saw several paintings by Segantini, including Death, *reproduced in color in the magazine* Jugend *around 1906. Segantini's "cross-stitch" brushstroke and solid forms inspired Hartley's first mature paintings.*

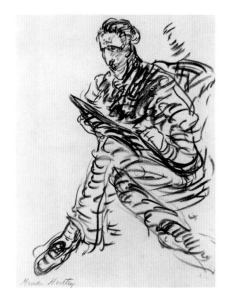

Self-Portrait as a Draughtsman

Hartley drew many self-portraits that winter, perhaps out of loneliness. The gawky pose reveals his shyness and vulnerability.

teel impressions of atmosphere and light, like "fine old tapestries—Paisley shawls and Persian rugs," as objects, not surfaces. Later writing of Segantini's influence on him, he said, "I have at least felt that you understood too thoroughly the THING-ness of things. . . . Mountains are things. . . . Through you I have learned the meaning of the appearances of all mountains."[2]

Despite Hartley's admiration for Segantini, his approach was distinctly different: Segantini never showed the mountains alone; they were always viewed in the presence of man and seen at a distance. In Hartley's paintings, the mountains moved aggressively forward and the people disappeared. Whether bathed in sunshine or voluptuously adorned with autumn leaves, these mountains ignore us, however grateful we are to see them. Nonetheless, the human presence in Segantini's work was precisely what attracted Hartley to it. Persistently, in nearly every instance where Hartley successfully painted mountains, it was because humanity—or more specifically a particular man—inspired him to do so. The human presence motivated him, but paradoxically, Hartley never managed to irradiate nature with that human presence. The inability to bring the human compulsion which prompted the work ultimately to bear on it is what drives the huge pressure that lies behind the forms. We nearly always sense the strain of Hartley's loneliness, his desire to make contact and his inability to do so. The romantic condition of alienation from nature and from mankind lay at the heart of Hartley's art. Desperately he tried to join the two things he loved best—the elevating mountains and the energizing presence of people—but finally he connected to neither. This emotional strain energized his work, a ceaseless, even relentless yearning.

Hartley's change of direction was confirmed by sales from his first exhibitions. Buoyed by his success he managed to survive the winter of 1908 in bitter isolation in North Lovell, Maine, living in an abandoned farmhouse which got so cold at times that he needed two stoves going continuously to keep warm. As

Cosmos

1908–9. Oil on canvas, 30 x 30⅛"
Columbus Museum of Art, Ohio.
Gift of Ferdinand Howald

The title, inspired by Emerson's and Whitman's transcendentalism, suggests this is nature's truest aspect, when "the rich sober yet powerful color [of winter] will have come upon the mountains," as he told Horace Traubel.

his self-portrait suggests, it was a very tough time, and one which he remembered with fear the rest of his life.

Nonetheless, Hartley was convinced of the strength of the paintings and took them to Boston to show them off. There, Maurice Prendergast arranged for him to show them to Robert Henri and William Glackens in New York. The artists of The Eight—an antiestablishment group including these three artists which had exhibited for the first time the year before—were interested. But before they could do anything, Hartley met Alfred Stieglitz who promised him a show in his gallery, 291. The introduction was pivotal.

Hartley had heard of Stieglitz since at least 1898, when he had cut out photogravures of Stieglitz's views of Venetian canals to color them in for his niece. But if he remembered his early daubs, he would have thought of Stieglitz as a photographer, not a dealer (Hartley confessed that at the time he had heard of only one dealer, William Macbeth). But Stieglitz was much more than just a photographer or dealer. Through his gallery—"the largest small room in the world," as Hartley would later describe it—and his periodical, *Camera Work*, Stieglitz was laboring to change the face of American art by introducing to artists and the public the latest European avant-garde creations. It was in

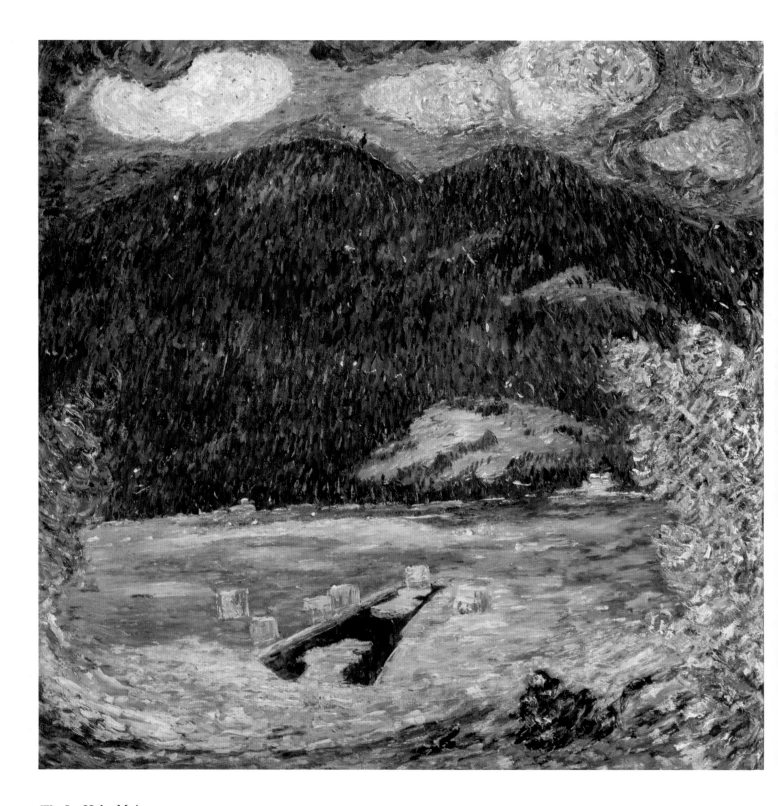

The Ice-Hole, Maine

1908–9. Oil on canvas, 34 x 34″
New Orleans Museum of Art. Museum purchase:
Ella West Freeman Matching Fund

Cosmos, Carnival of Autumn, Sum-
mer Camp, *and* The Ice-Hole *are part
of a series of ten views of the same
mountains exhibited in Stieglitz's gal-
lery, 291, in 1909. They compose a suite
of the seasons, in which color and atmo-
sphere are emphasized "rendering the
God-spirit in the mountains."*

The Summer Camp,
Blue Mountain

1908–9. Oil on canvas, 30⅛ x 34⅛"
The Fine Arts Museums of San Francisco.
Gift of Mr. and Mrs. John D. Rockefeller III

The ranges Hartley obsessively painted lay not far from North Lovell, in the Stoneham Valley near Lake Kezar, in Maine. Lee Simonson (later a stage designer), whose studio Hartley first used in Paris, worked at this summer camp and met Hartley while he was doing these paintings.

Maine Snowstorm

Stieglitz's gallery that Picasso, Cézanne, and Matisse had their first exhibitions in New York; and it was through *Camera Work* that the latest ideas about art were promulgated in America. There Hartley met all the artists who had just returned from Paris, artists who had met Picasso and Matisse, had seen their art as it was made: Max Weber, Abraham Walkowitz, and others who had been students with Hartley at the National Academy. He had been isolated for years in Maine; they had been in Paris.

The importance of Stieglitz for Hartley, besides his acting as Hartley's dealer on and off for almost thirty years, was that Stieglitz turned Hartley decisively away from his lingeringly sentimental Post-Impressionist manner and lit in him a fire to compete on an international stage with the leading radical artists of the day. Hartley seems to have had little commercial sense up to this point, little sense of what he should be as an artist or how he should go about placing himself. Stumbling onto Stieglitz gave him goals and directions which were to lead him for the rest of his life. But if Stieglitz ever felt he could dictate for long what his new protégé should do, he was much mistaken.

Hartley's first exhibition at 291, in May 1909, contained the fruit of the last desperate year in Maine: a suite of paintings all focused fixedly on the same mountain and lake as the world swirled around them, including both more descriptive works, like *The Ice-Hole* and *The Summer Camp*, and the more self-consciously Grieg-like *Hall of the Mountain King*, *Cosmos*, and *Songs of Autumn*. While Hartley disclaimed some of the titles later, the show was intended to have a coherent effect, a commingling of high-minded romantic "northern" poetry and music.[3] The paintings were as beautiful and as original an interpretation of Post-Impressionism as the celebrated Maurice Prendergast's. But Hartley faced a difficult question when he saw them in 291 instead of his ruinous farmhouse in Maine: Where did he go from here?

As Hartley remembered it, just as important as the exhibition at 291 was the reaction of one visitor, the dealer N. E. Montross. Montross invited Hartley back to his gallery to see a painting by Albert Pinkham Ryder, a visionary American painter whose work seemed to Montross to be similar to Hartley's. "It was a picture that so affected me that I in all truth was never the same after the first moment. . . . I was a convert to the field of imagination into which I was born. I had been thrown back into the body and being of my own country as by no other influence that had come to me."

Ryder's painting clarified for Hartley what it was that he had been doing: he had not been painting nature, he had been imaginatively seeking its heart. There *was* a New England landscape which lay beneath its obvious surface, and Ryder's painting told him he was on the right track. "The next pictures I did were solely from memory and the imagination." Hartley camped in a friend's studio around the corner from where Ryder lived and managed to see his new hero. And best of all Montross offered to support him at four dollars a week.

But Ryder's painting also validated his darker emotions, and these soon poured forth. Ryder was for Hartley the Emersonian transcendental being, alert to his relationship with a greater soul. At the same time, he was an awful exam-

Albert Pinkham Ryder,
Moonlight Marine

c. late 1890s. Oil on panel, 11½ x 12"
The Metropolitan Museum of Art, New York.
Samuel D. Lee Fund, 1934

This is the painting shown to Hartley by the dealer Montross, his first, staggering sight of Ryder's paintings: "It was a marine by Albert P. Ryder—just some sea—some clouds—and a sail boat on the tossing waters. . . . I felt as if I had read a page of the Bible."—Hartley, "Somehow a Past"

Maine Snowstorm

1909. Oil on canvas, 30⅛ x 30⅛"
Frederick R. Weisman Art Museum,
University of Minnesota, Minneapolis.
Gift of Ione and Hudson Walker

Hartley had to keep two stoves going to stay warm in his abandoned farmhouse, but despite the cold and the isolation, the blizzards were wildly exhilarating. He exhibited the snow scenes in 1909 as "Songs of Winter."

The Dark Mountain No. 2

1909. Oil on composition board, 20 x 24"
© 1993, Alfred Stieglitz Collection, 1949.
The Metropolitan Museum of Art, New York

Inspired by Ryder, he wrote to his niece on July 15, 1910: "I do not sketch much these days for I work almost wholly from the imagination—making pictures entirely from this point of view using the mountains only as backgrounds for ideas."

The Dark Mountain No. 1

1909. Oil on composition board, 14 x 12"
© 1993, Alfred Stieglitz Collection, 1949.
The Metropolitan Museum of Art, New York

Stieglitz, who owned this painting, wrote on the back: "I still consider it one of the best of all Hartley's work. . . . Hartley was undoubtedly on the verge of suicide during the summer which brought forth this picture."

ple of what Emerson called compensation: the price of his great gifts was loneliness, slovenliness, poverty, all the things that Hartley, a social being who liked the things of the world, was horrified at but sensed he was doomed to. The core of Ryder's tragedy was "the love image and love denial, he to whom love had been denied," Hartley later wrote. Was this going to be the inevitable result, the price for giving in to the impulses which he felt and which Ryder so clearly did too? As he wrote to Horace Traubel's wife, Anne, from Maine about his complicated relations to nature and art:

I lose the great purport of all silent things in the craving for the sweetest of things—companionship—I am free to confess that as yet art has never been more than love and friendship nor has it been less. . . . I do not crave to go from them [the mountains]—I desire only a human hand to touch, a big broad shoulder to brush by—a wondrous deep souled eye to look into—a smile to be conscious of upon a face somewhere near. Then the ceaseless rushing of the waterfall . . . would have the right meaning.

After the great critical success of the Stieglitz show came the inevitable collapse of his hopes: nothing sold and he was in despair. Stieglitz said that Hartley had been suicidal. The paintings he produced that summer and fall, inspired by Ryder, he called the "black" or "dark landscapes." They revolved monotonously around fantasies of abandonment and desolation and suicide: in *The Dark Mountain No. 1* he rendered his lonely farmhouse in North Lovell as though it were

The Dark Mountain No. 1

Landscape No. 20, Resurrection

1909. Oil on board, 13½ x 11½"
Private collection, Courtesy Vanderwoude
Tananbaum Gallery, New York

Hartley was inspired by William Blake's paintings to include mystical figures in his work. The overlapping centered forms provide the basis for his later abstractions.

Landscape No. 25

c. 1910. Oil on composition board, 12 x 12"
© 1993, Alfred Stieglitz Collection, 1949.
The Metropolitan Museum of Art, New York

Influenced by Matisse and his American followers such as Max Weber, Hartley began to use livelier colors and bolder brushstrokes in 1910.

swallowed up by the black, blank hills that brood over it, hills that he had painted the previous year as alive with color. The trees in the foreground are dead but writhe grotesquely in a parodic memory of life, acting out the sense of sterility that Hartley felt. The paintings are repetitive meditations on suicide and failure, distance from home and refuge, the oppressive power and indifference of nature. It was not just the fear of poverty, which he had inherited from his father and plagued him all his life, or the lack of recognition that consumed Hartley. It was his sense of physical isolation.

But Hartley was always amazingly resilient, as he himself liked to boast. Depressive as these paintings were, they also revealed an innovative change in his technique. Inspired by Ryder's labored surfaces and restricted palette, Hartley began to scrape and scratch the paint, as in *The Dark Mountain No. 2*, mixing and overlapping areas of different texture and consistency to give his canvases weight and density. Such heavily worked surfaces, never light and glossy like

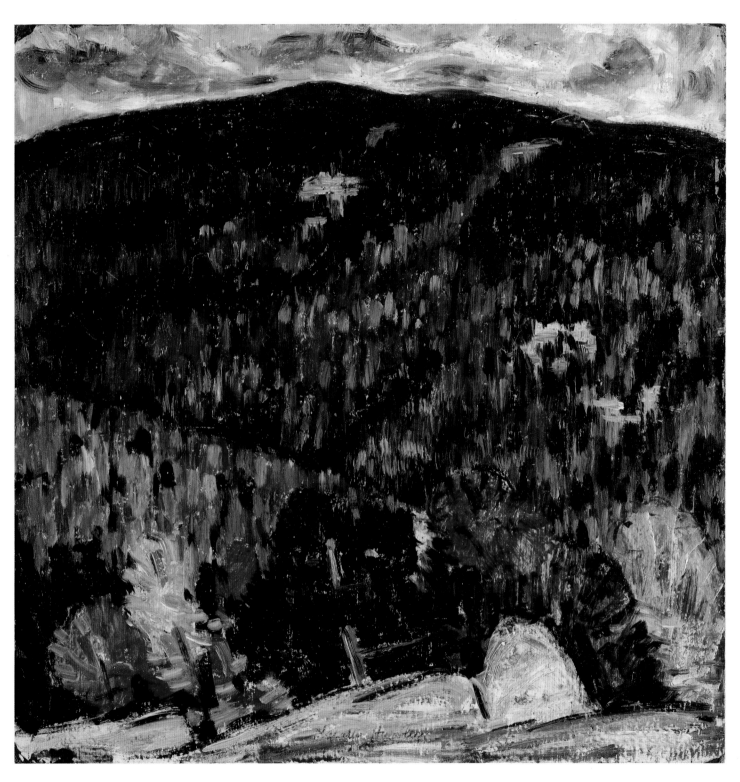

Landscape No. 25

Carnival of Autumn

c. 1910. Oil on board, 12 x 12"
Portland Museum of Art, Maine.
Lent by Chris Huntington

*A favorite motif was the screen of trees
laced across the foreground, emphasiz-
ing the density of the picture's surface.*

Landscape (Waterfall)

1910. Oil on board, 12 x 12 "
Courtesy of The Fogg Art Museum,
Harvard University Art Museums, Cambridge,
Massachusetts. Gift of James N. Rosenberg

Perhaps one of the three paintings of waterfalls he exhibited in 1910. As he wrote Paul Strand's wife, Rebecca, in 1930: "How I love falling water. No lake or pond ever gives me what a waterfall can."

those of his rival at Stieglitz's gallery Georgia O'Keeffe, remained fundamental to his art.

By the time Hartley returned to New York early in 1910, after a long visit to Lewiston, he had regained a sense of balance. In New York he was able to see for the first time what everybody had been raving about in a show of Matisse at 291 in February. The works confirmed his sense of color and the need to paint more physically and directly. The series of small panels he now embarked on (*Landscape No. 25, Carnival of Autumn,* and *Landscape [Waterfall]*; pages 31–33) explored the technical release of the "dark landscapes," but without their soul-destroying emotion. The next year he saw his first Picassos, and attempted an abstract composition (on the back of a nude study from art school). Later that summer Hartley saw his first Cézannes and was immediately converted, although at first he knew him only through black and white reproductions, not seeing any paintings until the autumn of 1911 in New York at the home of the Havemeyers, early collectors of the Impressionists. The combination of these three artists, as well as the paintings of their American followers such as Max Weber, convinced him that the "new art" was based on still life, not landscape, and for most of 1911 he forsook his first love. Cézanne's still lifes, in particular, embodied the same sense of form he had felt in the landscape of Maine, implacable as mountains but concentrated and close at hand. Hartley responded to Cézanne's apples with a series of monochromatic still lifes of pears and bananas. These are more voluptuous fruits than Cézanne's, so that despite the fact that Hartley has given up color for compressed and disciplined form, something sensual still stirs beneath the surface. Returning to these motifs much later, he would develop this hint of carnality.

Hartley's swift abandonment of his beloved landscapes testified to his eagerness to remake himself as a modern artist, and the impractical willingness he showed to abandon the very things which made up his success, unlike such contemporaries as Prendergast and John Marin, who stuck to the same manner their whole careers. In a long history of such stratagems, this was probably his first major mistake, in part made at Stieglitz's urging. Hartley's new allegiance to still life also meant he had abandoned his strongest impulses, spiritualism and transcendentalism. But he clearly thought the exchange was worthwhile. His exhibition in February 1912 was successful, as if to confirm the change of direction, and Stieglitz arranged for support for him to go to Europe. "So much for long struggles and faith in oneself," he triumphantly declared, and set off across the Atlantic.

Pears

1911. Oil on wood, 16 x 12½"
Bequest of Hudson Walker from the Ione and Hudson Walker Collection, Frederick R. Weisman Art Museum, University of Minnesota, Minneapolis

Under Stieglitz's influence, Hartley transferred his allegiance from landscape to still lifes. In the summer of 1911, Stieglitz sent him photographs of Cézanne paintings, inspiring several paintings and an undying love of Cézanne's work.

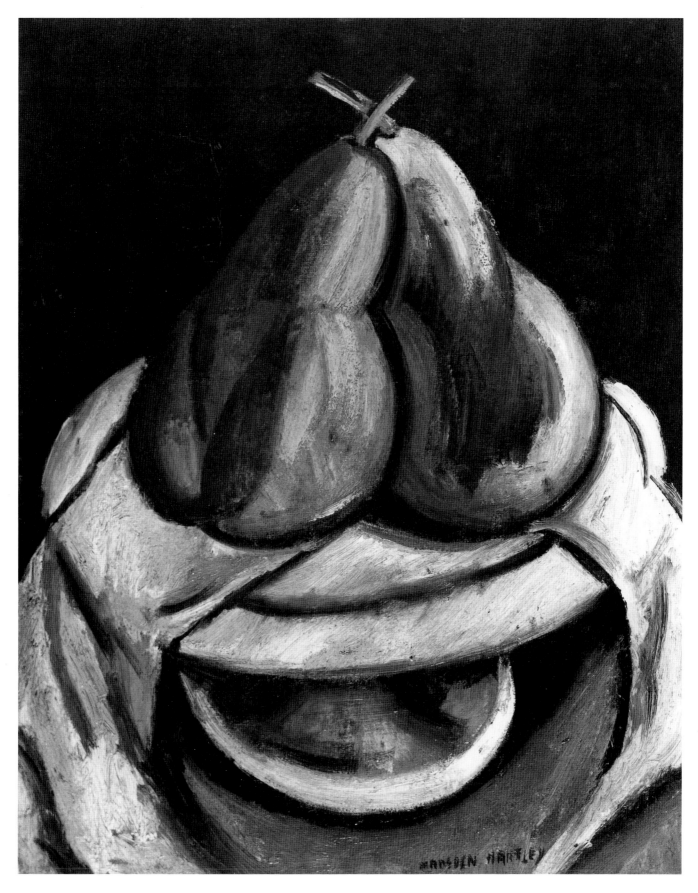

Pears

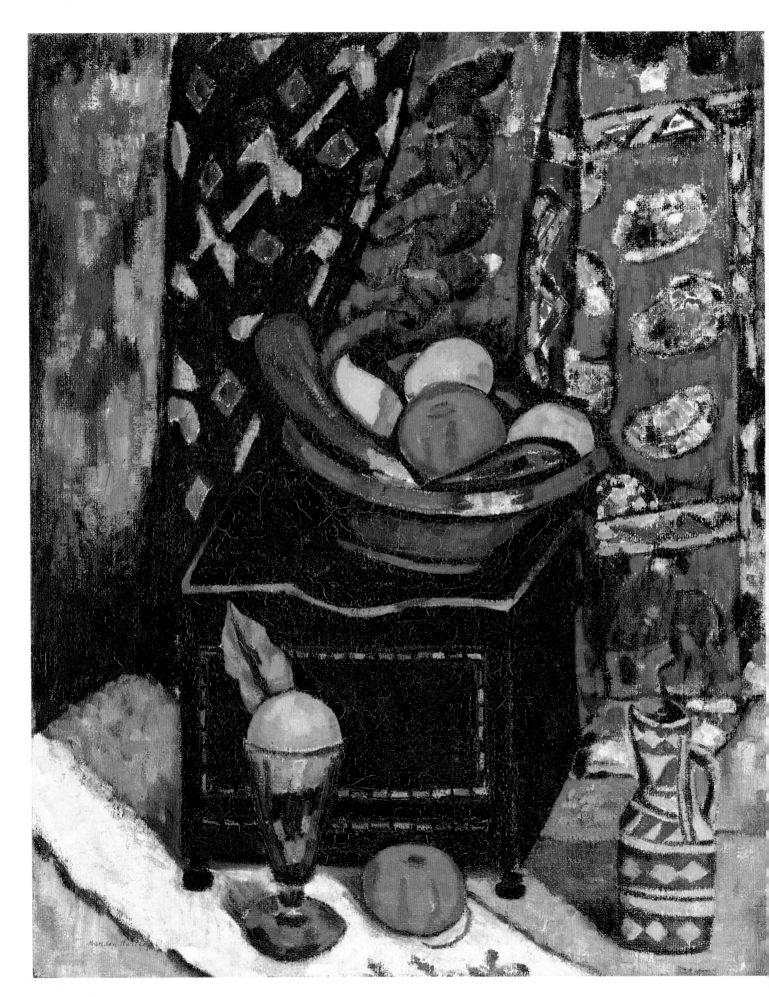

Still Life No. 1

III. Paris, 1912–13

ARIS! AT LAST REAL LIFE WAS GOING TO BEGIN! After a few days of bewilderment, Hartley located friends from New York, found a studio, and began looking at art. He first explored the commercial galleries for the avantgarde work that he had seen in New York in dribs and drabs. Only after that need was satisfied would he go on to the Louvre. What Hartley wanted was the latest thing, the modernist, Cubist assault on traditional art. Ironically, he found in Paris that what he was really looking for was German art and Germany.

Initially, Hartley associated himself with the American community, which meant maintaining his interest in Matisse and Cézanne. *Still Life No. 1*, one of the first works he completed in Paris, makes his response clear: there is a little bit of Matisse in the color and a lot of Cézanne in the structure. But Hartley's dexterous imitation of the standard American interests soon palled; he was temperamentally unable to join a crowd for long. The first sign of his independence could be seen in his friends. He decided not to have coffee at the Dôme, where most of the Americans hung out—and played billiards; Hartley went across the street to La Rotonde, where he could be more serious and aloof, and had dinner at Restaurant Thomas. There in June he made new friends—Germans—who changed his life irrevocably: Arnold Rönnebeck, a sculptor, and his cousin, Karl von Freyburg, "the handsome officer," as Hartley named him to Stieglitz (who, one must remember, was also of German extraction). It was through them, particularly Rönnebeck, that Hartley learned the sophisticated and degenerate side of urban life, something he had not tumbled into, or barely touched, despite all his years in New York. Hartley, many years later, told a baroque story of a student in Paris who visits an Apache prostitute and barely escapes death.[1] Clearly based on one of Rönnebeck's adventures, it gives an idea of the different flavor of Hartley's Parisian life: no transcendentalist self-denying colonies for him in Europe.

One American did make a difference, and that was Gertrude Stein. Stein's famous salon in her apartment at 27 rue de Fleurus was open to anyone interesting and was crowded with Americans discovering the latest thing: Stein introduced more American artists, critics, and collectors to Cubism than any other person. Hartley later recalled how impressed he had been by the rows of Picassos and Matisses: "they seemed to burn my head off—I felt indeed like a severed head living off itself by mystical excitation."

It was the Picassos that mattered most, a judgment reinforced when Stein introduced Hartley that fall to the great artist himself, younger than Hartley by four and one-half years. Picasso was the dominant—even indomitable—force in

Still Life No. 1

1912. Oil on canvas, 31½ x 25⅝"
Columbus Museum of Art, Ohio.
Gift of Ferdinand Howald

Hartley visited the Trocadéro Museum to see "primitive" art as an antidote to French theorizing. There he saw the Native American Pueblo Indian jar and the strongly patterned folk fabrics he used in this still life: "These people created out of spiritual necessity."

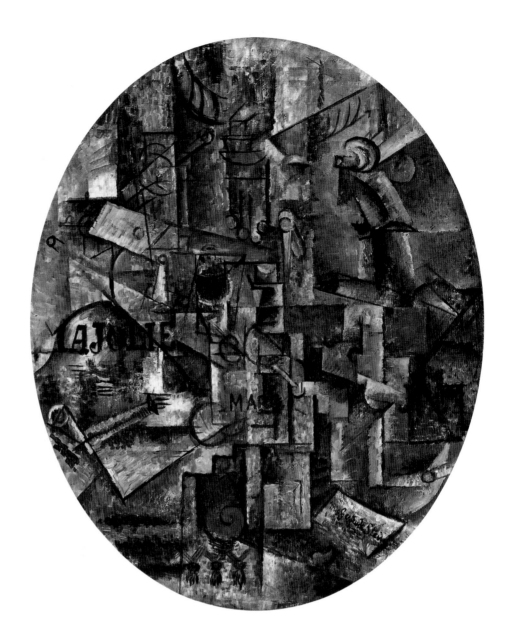

Pablo Picasso, *The Architect's Table*

1912. Oil on canvas mounted on
oval panel, 28⅝ x 23½"
The Museum of Modern Art, New York.
The William S. Paley Collection
© ARS, New York/SPADEM

Hartley saw this Picasso at Gertrude Stein's and wrote to Stieglitz: "He is doing things that have running over and across these network designs names of people and words like 'jolie' or 'bien' and numbers like '75.'"

Paris. Everything he did sparked reactions; the art world seemed to center itself around him. And Hartley arrived in time to appreciate the reaction of that world to Picasso and Braque's invention of Cubism, which was evident in the Salon d'Automne and Section d'Or exhibitions that October. But the contributions of other artists—including Braque's—paled beside Picasso's work. Hartley's first sight of a full Analytical Cubist still life by Picasso, *The Architect's Table*, which Stein had just bought, left an indelible impression. "I say Picasso over and over—because in my esteem he has proved himself to be the most gifted in visualizing his sensations of any man at this time."

But while Hartley was entranced by the possibilities of Cubism, he felt distaste for the talk surrounding it. After going to Robert Delaunay's studio to see his "latest," he complained: "but so far it is like a demonstration for chemistry of the technical relations of color and sound. They all talk so glibly but what do they produce." This French affectation—smooth talk and smooth manners—

grated on Hartley and soon became a set prejudice against the French in general. Picasso, of course, was not French and, more important, did not theorize or claim to theorize, at least according to Hartley: "Picasso says he has no theories—but only does these things because he likes to. This places him among the immortals already."[2] For Hartley, as ever, painting was a matter of the heart.

Hartley's initial responses to Picasso's works—such as *Musical Theme No. 2 (Bach Preludes et Fugues)*, painted in the early autumn—at first sight look like the many other first stabs at Cubism attempted by young artists everywhere in this period: fractured planes are piled up in a shallow, rather colorless space. Even the subject may be compared to Braque's *Hommage à J. S. Bach* from the same year. The fact that August Macke, a German Expressionist artist, also painted an *Hommage à Bach* that year suggests the universality of the subject. But Macke's painting also points to the other model Hartley discovered in Paris, for in discovering Germans he also discovered German artists.

The most important was Vassily Kandinsky. The summer that Hartley encountered Picasso was also the summer that, with the help of his German friends, he haltingly read *Der Blaue Reiter* almanac and Kandinsky's *Über das Geistige in der Kunst (On the Spiritual in Art)*, of which "the mere title opened up the sensation for me and from this I proceeded." That is, the sensation of spirituality, which he had missed amidst the determined materialism of French art. It was Kandinsky's call for an art that made connections to man's deepest feelings which gave Hartley the confidence in September to begin his first series of abstract paintings—that and the perception that the other avant-garde painters were not as good as they thought they were. He realized that he was positioning himself between Kandinsky and Picasso but also knew his difference from them. Picasso had shown him the way "to produce my deepest sensations and organize my vision as much as possible—leaving out all reliance upon the emotional aspects of one's temperament—seeking but one object, real expression." But it was Kandinsky who led him to his "recurrence of former religious aspirations." Hartley felt he had achieved in his own abstract paintings "the first expression of mysticism in modern art." But despite his claim that he was leaving personality behind, he was well aware of how personal the paintings were. Contrasting himself to Kandinsky, he told Stieglitz: "Kandinsky would stir the mind to action—arouse a thought. I seem only to arouse the self as I myself am stirred. . . . I do not ask so much of a picture."

Painting No. 1 (page 42) demonstrates how Kandinsky influenced Hartley visually. Many of the specific shapes are adapted from Kandinsky's *Study for "Composition No. 4"* (page 43), which had been reproduced in *Der Blaue Reiter*: the layered, rising peaks, the distant sun, the lines which cut across the canvas. Both are transformed landscapes (not still lifes!), but while Kandinsky's has space and atmosphere, Hartley's has no breathing room, with everything pushed to the front, as in his Maine landscapes. And he includes artificial signs, elements derived from Picasso.

Hartley summed up the intellectual sources of his abstraction by explaining to Stieglitz: "I came to it by way of James' pragmatism, slight touches of Berg-

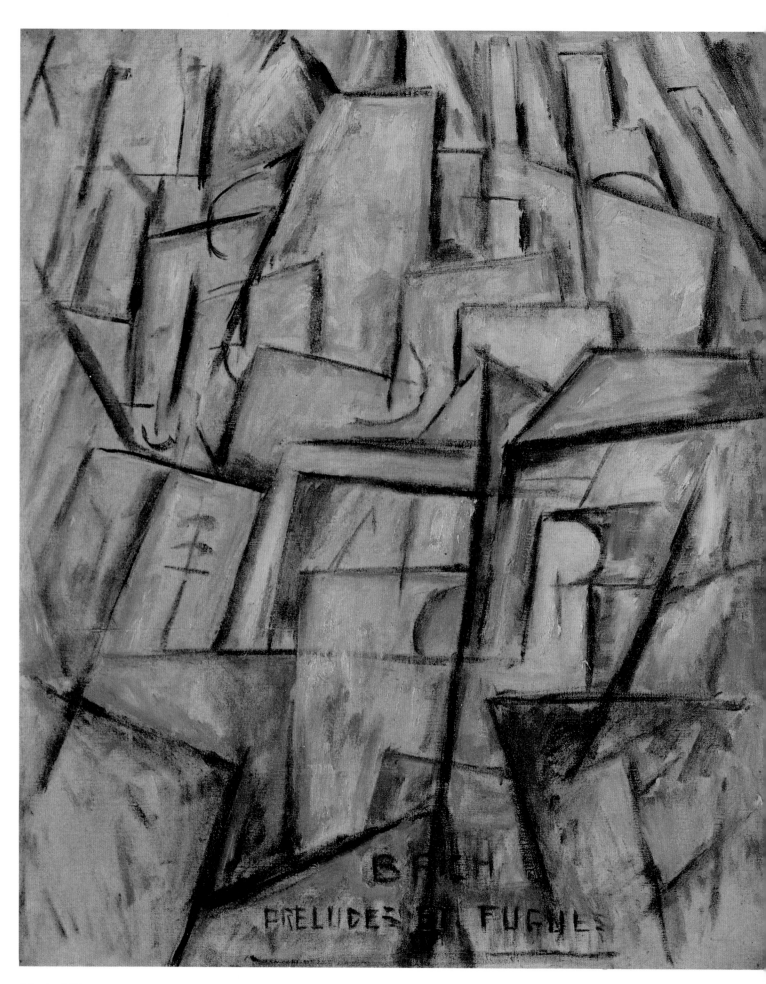

Musical Theme No. 2 (Bach Preludes et Fugues)

son, and directly through the fragments of mysticism that I have found out of Boehme, Eckhardt, Tauler, Suso and Ruysbroeck, and the Bhagavad Gita." His list of sources, from William James to medieval mystics to ancient Indian epics, indicated that what Hartley meant by abstraction was mysticism. So intent was he that he could see even Picasso as "a most abstract psychic nature."

For Hartley, abstraction was the record of an inner experience, one governed by emotion not logical analysis. Quoting the philosopher Henri Bergson, Hartley declared: "Intuition is the only vehicle for art expression"; the particular intuitions that concerned him were mystical. Theosophy, with its emphasis on the occult and Eastern religion (to which *Musical Theme [Oriental Symphony]*, page 44, paid homage), dominated mystical speculation at the time; but Hartley preferred more practical, scientific studies, such as William James's *The Varieties of Religious Experience* (1902; see page 46) or Richard Maurice Bucke's *Cosmic Consciousness* (1901).

In the realm of the mystic, as Bucke put it, "ordinary things are transformed." For Jakob Böhme (a sixteenth-century German mystic who was Hartley's favorite; see page 45), revelation began with natural things. As James and all others insisted, a mystical experience arises in direct experience but leads to a state which cannot be translated into words—that is to say, it is the real thing, more real than the trivial realities of Hartley's life, the unfortunate facts that he was homosexual, poor, had little formal education, and was not particularly good-looking. Hartley's mystical experiences—or rather, the search for them—rendered those inconvenient and even hostile realities irrelevant; as James wrote, higher states of consciousness reconciled mundane existence, "as if the opposites of the world . . . were melted into unity."

Evelyn Underhill's *Mysticism: A Study in the Nature and Development of Man's Spiritual Consciousness* (1911), a book which Hartley repeatedly recommended to his niece Norma, who was a Christian Scientist, associated together "religion, pain and beauty." Religion would redeem the pain and transfigure or preserve the beauty. Religion's final end is "pure love." Underhill's study reassured Hartley, no doubt, that his psychological pain and suffering marked him out as belonging to "the highest types." Underhill asserted, like the mystics she studied, that through religion, pain, and art we arrive at worlds which are not "accessible" to the senses, "worlds glorious and immortal, whose existence is not conditioned by the 'given' world which the senses report." That is, worlds which transfigured the sordid conditions of much of Hartley's existence. For him, mysticism was sincere sublimation.

Furthermore, mysticism gave Hartley a specific vocabulary of graphic signs to work with, both geometrical shapes like circles and pyramids, as well as "letters" like astrological symbols (which were so much more satisfyingly resonant and mysterious than Picasso's pedestrian "Jolie" and "bien!"). It also, as Böhme's diagrams demonstrated, confirmed Hartley's instincts for pictorial space as something flat, with large shapes pressing close to the surface. The symmetry of such diagrams Hartley generally ignored: he presented a personal vision in flux, not a perfected, universal image. As Underhill insisted, the more suggestive the

Musical Theme No. 2
(Bach Preludes et Fugues)

1912. Oil on canvas, 24 x 20"
Thyssen-Bornemisza Collection,
Lugano, Switzerland

"B. is for Bach . . . who wrote square music for nave/and for loft,/for arch and for aisle,/for all the lost, forsaken things/no other sound will save."
—*Hartley,* Collected Poems

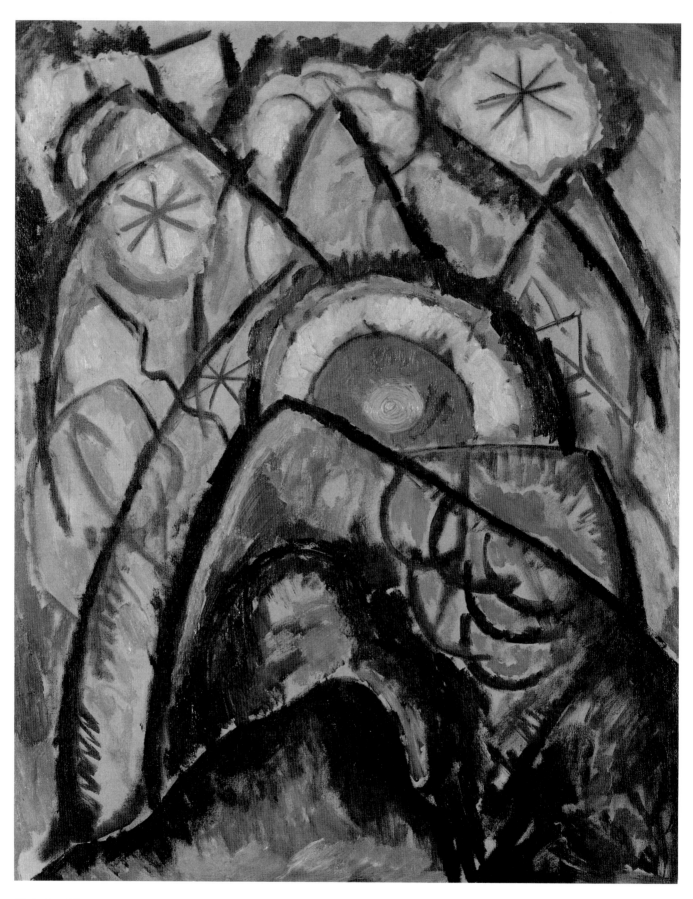

Painting No. 1

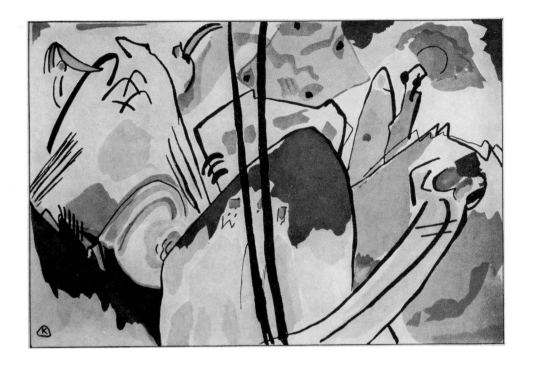

symbol, the greater the emotional response; the appeal of such painting was not "to the clever brain, but to the desirous heart, the intuitive sense of man." It is this "desirous heart" which concerned Hartley, his own desiring of love. Ultimately, then, abstraction was autobiographical; it was based on real experience, both physical and spiritual, and Hartley meant to ignore neither aspect.

But theory was one thing and practice another. Hartley recorded the process of making the paintings, and it is a revealing one: "[I] thought I would just take some canvases and begin more or less in the style of automatic writing and let my hand be guided as it were—and I made lines and curves—stars and various images and colored them lightly so that the whole effect came to have an inspirational and transcendent quality. I found after I had done one, I could do more and they began to be sort of portraits of moments. They were of good size, about 30 x 40 inches and I did at least 20 of them."

While Hartley recorded the impulse behind the paintings as spontaneous and free flowing, in fact the paintings show considerable thought. In the set of four paintings in homage to Bach, a predominant rhythm of shapes—sharp angles or the blunt ends of trapezoids—characterized different types of music. In *Musical Theme No. 2 (Bach Preludes et Fugues)* (page 40), for example, the squared ends of the triangles march deliberately and firmly across the canvas, mimicking the music's sense of right-angled architectural solidity; *Painting No. 2 (Bach Prelude)* (page 47), however, has jagged peaks, indicating a faster, livelier rhythm. The deliberation behind these paintings is made clearer when one realizes that in fact two sets of them exist—an initial group 24 by 20 inches in size and a larger final version of the same compositions, about 40 by 32 inches.

Gertrude Stein saw these paintings and borrowed four (including *Painting No. 1*), declaring: "Well, Hartley, I wasn't expecting anything like this—I really

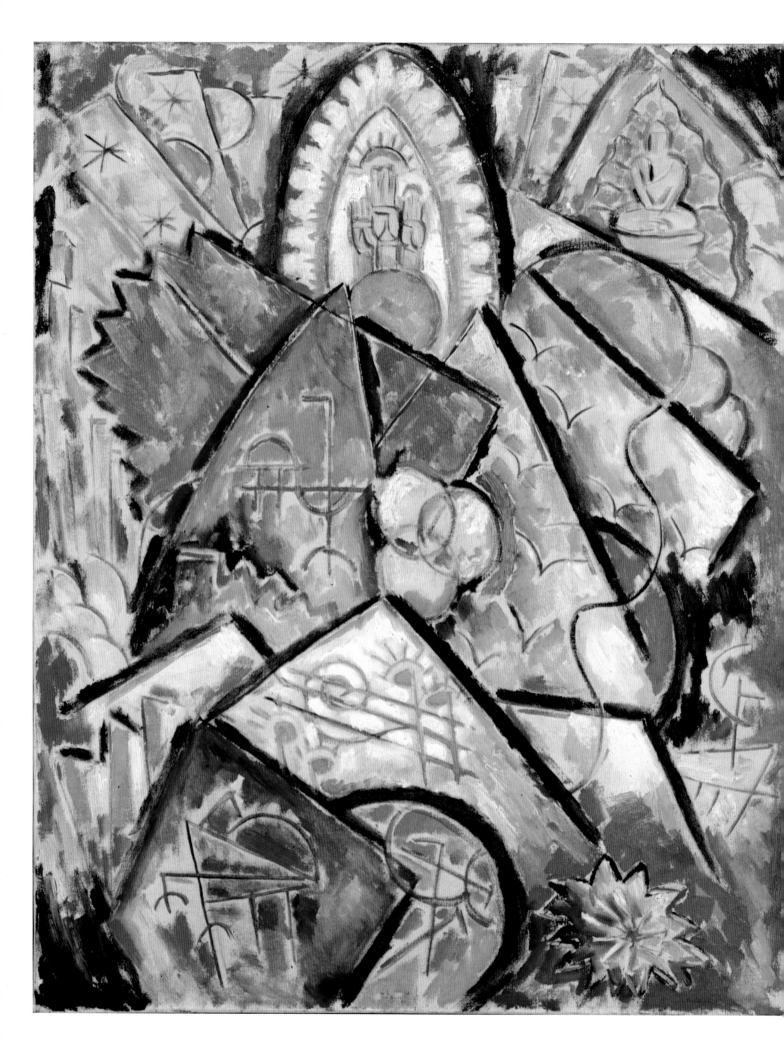

Musical Theme (Oriental Symphony)

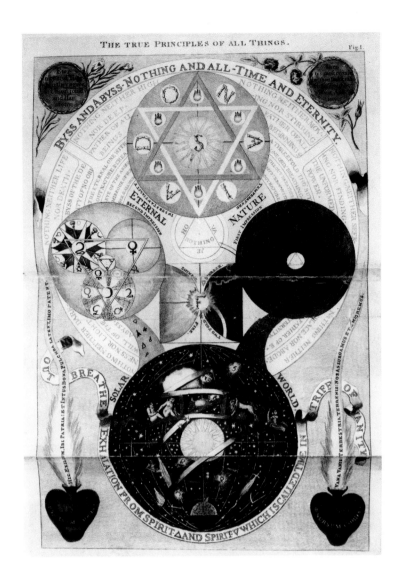

THE TRUE PRINCIPLES OF ALL THINGS.

The True Principles of All Things.
From *The Works of Jakob Böhme,*
vol. III, The William Law edition,
published by G. Robinson,
London, 1772.

Diagram. The Manly P. Hall Collection,
Philosophical Research Society, Los Angeles

Jakob Böhme was a sixteenth-century German mystic Hartley began to study in Paris. This diagram, typical of the ones illustrating Böhme's work, helped inspire Hartley's interest in circles, stars, and triangles.

like them—at last an original American." But the reaction of other Americans was less satisfactory. Arthur B. Davies visited his studio to find work to exhibit in the Armory Show, but preferred the more conventional still lifes. And, more horrifying, the "occultistic wife" of an American journalist saw them and told him they were "full of kabbalistic signs and symbols—and I felt taken down—for I had no intention or hope of being profound. It upset me."

What was the cause of Hartley's upset? He wanted the paintings to be auto-biographical, unsystematic, and private. Hartley, for example, never joined any theosophical group: he preferred working it out on his own and resisted being led by anyone. Hartley argued very strongly, in 1913 and later, both against theory and against seeing art as a succession of styles or problems solved. Art was autobiographical adventure—the person in paint (an attitude in harmony with the literary criticism of his day). As he stated in January 1914 in the catalogue of the exhibition at 291 of his first European pictures: "The intention of the pictures separately and collectively is to state a personal conviction—to express a purely personal approach. It has nothing whatsoever to do with the prevailing modes and tendencies—cliques and groups of the day. It has no intel-

*Musical Theme
(Oriental Symphony)*

1912–13. Oil on canvas, 39⅜ x 31¾"
Rose Art Museum, Brandeis University,
Waltham, Massachusetts.
Gift of Samuel Lustgarten

Oriental Symphony is full of Eastern religious symbols, from the little silver Buddha that Hartley owned to the three hands in a mandala forming, as Gail Levin suggests, the abhaya mudra sign, meaning "Have no fear."

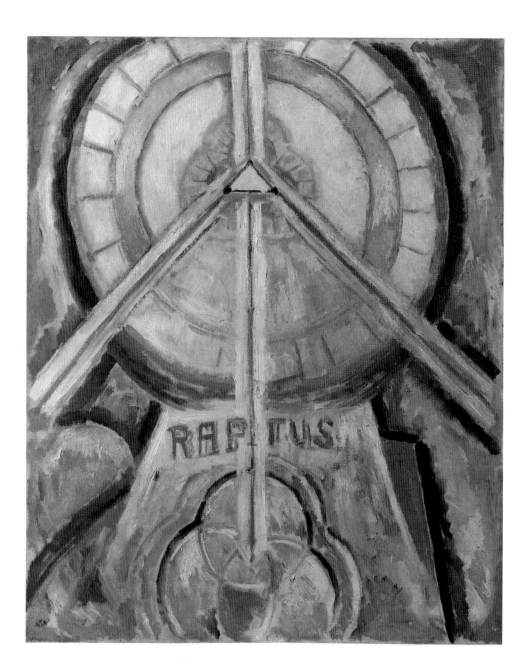

Raptus

1913. Oil on canvas, 39⅜ x 31¾"
The Currier Gallery of Art, Manchester,
New Hampshire. Gift of Paul and Hazel Strand
in memory of Elizabeth McCausland, 1965

This meditation on the word raptus, *as used by William James in* The Varieties of Religious Experience *to signify the moment of complete mystical union with God, is closely allied to Böhme's mystical diagrams.*

lectual motives—only visionary ones. . . . The essential of a real picture is that the things which occur in it occur to him in his peculiarly personal fashion. It is essential that they occur to him directly from his experience, and not be suggested to him by way of prevailing modes." Hartley no longer spoke as a provincial from Maine, and would not settle for American mannerisms and fashions.

Within the space of less than half a year, Hartley had found what he had sought: a personal style and vision which could compete with the most radical artists in Europe or America. During his first summer in Paris, he had sensed what was to come: "I feel as if it were such a vital period. One must protect it well from accidents and evil circumstances so that it may flower and be productive and that is all I want."[3] But this flowering was not to happen in Paris, as it did for the rest of the American expatriate modernist community. Just after Christmas

46

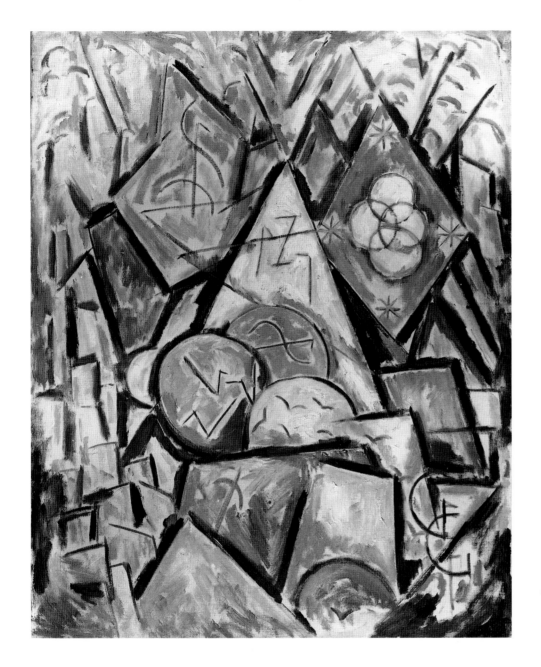

Painting No. 2 (Bach Prelude)

1913. Oil on canvas, 39½ x 31⅞"
Bequest of Hudson Walker from the Ione
and Hudson Walker Collection, Frederick R.
Weisman Art Museum, University of Minnesota,
Minneapolis

*Although Hartley claimed that his "cos-
mic Cubism" was created spontaneously,
for the suite of four Bach abstractions
both studies and larger finished works
exist. The study for this work is in a pri-
vate collection.*

that first year in Paris, Hartley went to Berlin to stay with Rönnebeck and his
family. On the way back, he stopped in Munich to visit Kandinsky and Franz
Marc, a visit which was to confirm his decision that his future lay in Germany.
As he wrote to Stieglitz: "It was during the five days in Munich that I found my
place in the art circles of Europe. . . . I have discovered my essential self here."

Gertrude Stein provided the satisfying conclusion to his work in Paris, an
indication of how far he had come. Stein had hung the drawing by Hartley she
had bought next to one of her Cézannes, and Picasso could not understand it.
Hartley trumpeted that he had gone beyond Picasso into the "pure spiritual."
"So you see my dear Stieglitz I am placed by this woman in the art scheme of
things in Europe and it won't be long before I shall be in the ascendancy in all
ways. There is everything here for me. I have all Europe at my hand."

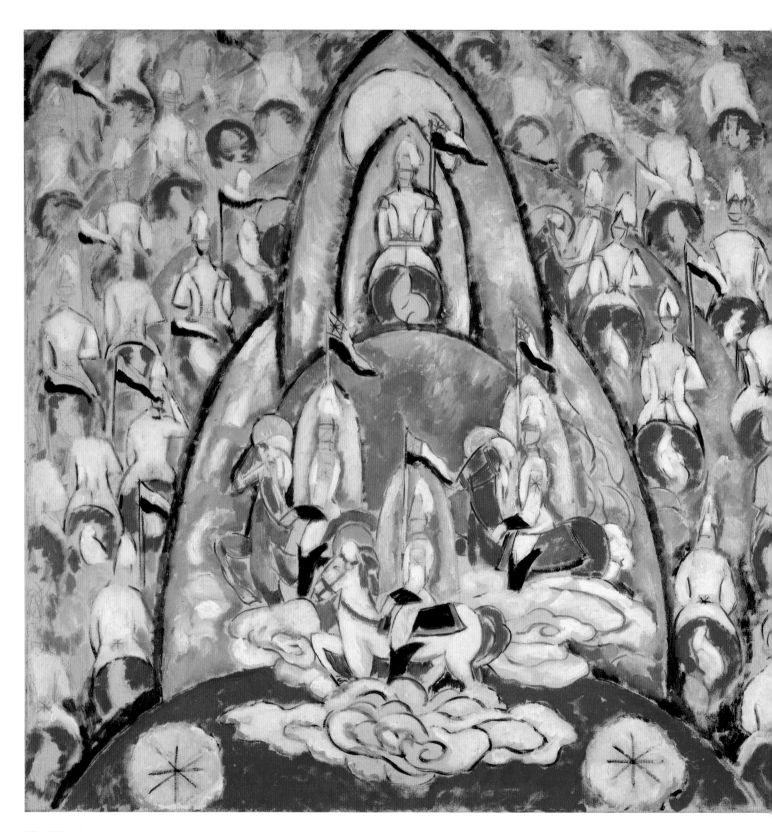

The Warriors

IV. Berlin, 1913–15

PARIS HAD AT FIRST SEEMED DARK and disappointingly not made of "mother of pearl." Berlin was another story. There, from the first visit in January 1913, Hartley saw "such spick and spanness in the order of life I had never witnessed anywhere—not merely because the military life provided the key and clue to everything then—but this sense of order flowed into common life—and such cleanliness prevailed as hardly to believe—the pavements shining like enamel leather." His reaction was sensual: "I had never felt such a sense of voluptuous tension in the air anywhere—it was all so warm to my long chilled New England nature and provided the sense of home always so needed in my life and which Germans so often tendered long before I found the way to go to Europe. . . . The whole scene was fairly bursting with organized energy and the tension was terrific and somehow most voluptuous in the feeling of power—a sexual immensity even in it—when passion rises to the full and something must happen to quiet it."

Despite (or perhaps because of) the intensity of his pleasure, it took him a few months to settle down to painting after his return in May. First he had to find an apartment and then money problems sapped his energy. But when he did pick up his brushes again, his Berlin paintings were immediately different from his Parisian abstractions. *The Warriors*, one of the first to be completed, is similar in its structure and thin colors to the earlier work, but it is full of specific, material references. In fact, it memorializes one of the parades that Hartley loved so dearly, part of the events celebrating the marriage of the daughter of the Kaiser to Herzog von Braunschweig in late May: "the Parises [*sic*] Platz was packed jammed to the stoops and windows with those huge cuirassiers of the Kaiser's special guard—all in white—white leather breeches skin tight—high plain enamel boots—those gleaming blinding medieval breast plates of silver and brass—making the eye go black when the sun glanced like a spear as the bodies moved . . . inspiring helmets with the imperial eagle—and the white manes hanging down—there was six foot of youth under all this garniture— everyone on a horse and every horse white—that is how I got it—and it went into an abstract picture of soldiers riding into the sun."

The Warriors represented the quintessential image of German life for Hartley: crowds, colorful pageants, cleanliness, and beautiful men, "thousands all so blonde and radiant with health," all gathered together under the aegis of the military. The ideals of an orderly, comradely society, which he had pondered under the influence of Whitman and Green Acre, here seemed, without irony,

The Warriors

1913. Oil on canvas, 47¾ x 47½"
The Regis Collection, Minneapolis

"[This painting] expresses his feeling of what he calls 'ecstasy' on the part of the dragoons at the maneuvers he had seen. A rising dome, the eternal symbol of endeavor weighted by the desires of the flesh."—Charlotte Teller, The Little Review, *November 1916*

49

to come to life. Just as important, his two best friends in Berlin, Rönnebeck and Freyburg, were soldiers.

While this adoration of military men might be the center of Hartley's life, it was not the only thing. *Portrait of Berlin* is a symbolic compendium of his private life, which balances his contemplative and active side between the Buddha and the soldier. Like the other Berlin paintings, the images are more concrete, more dense than the Paris abstractions, more full of specific, personal allusion. As Hartley had said of his youth, the connection between collecting things and sexual expression is close: the hypersexuality of Berlin lay under this need to get closer to the real world. His paintings were now more present and less abstracted and distanced than the Parisian works, in paint handling as well as subject, emphasizing the degree to which the mysticism of the earlier paintings consisted largely of sexual repression and displacement. But this is not to say that Hartley had found true love in Berlin with Freyburg, at least not at first (and probably he never had a sexual relationship with him). He complained to Stieglitz in June, at the height of his depression over money, with Freyburg and Rönnebeck both busy with military matters:

And too my life is just exactly the same here as in America. I see different things around me—but my own private life is precisely the same as it was, and as I suppose it always will be—I am not happy interiorly and this as far as I can see cannot be changed. Like any other human being I have longings which through tricks of circumstances have been left unsatisfied and I am not the kind to brush them by. . . . It leaves me with an inner need unsatisfied and the pain grows stronger instead of less and it leaves one nothing but the role of spectator in life watching life go by—having no part in it but that of spectator which of course is diverting but not satisfying to the soul of one which longs for a human place to be. . . . Anyhow here I sit—in another spot in Europe—knowing it is Europe and knowing also it is but another place to pitch the tent—for I am homeless actually—spiritually and every other way. . . . And there's no saying "Buck up and be different" for it is myself and I must always be that and be true to it—and live with it the best I can for I am eternally alone with it.

Ultimately, it was sexual love he mourned the lack of, the seemingly impossibility of love and sexual relationship coexisting, which would always reduce Hartley to the role of spectator, never participant. And to be a spectator was to use one's eyes only, to be an artist: for Hartley, his sexuality condemned him to the role of artist, the one who looks but does not act.

The thrilling "sexual immensity" of Berlin pressed Hartley to fasten the "mystical ideas" he saw everywhere around him onto concrete objects which resonated with his private life. His canvases presented tangible symbols jostling together, rather than a field of insubstantial impressions like Kandinsky or a display of banal objects like Picasso. His first abstractions in Paris had been beautiful and derivative; now he was beginning to find his own way.

The power and originality of his Berlin paintings were quickly recognized by other German artists, and during his years in Berlin he was pleased at their

Portrait of Berlin

1913. Oil on canvas, 39⅜ x 39⅛"
Yale Collection of American Literature, Beinecke Rare Book and Manuscript Library, Yale University, New Haven, Connecticut

Hartley found Berlin "full of mystical ideas. . . . I am seeing eight-pointed stars here by the thousands . . . on the Kaiser's breast it is always—on the helmets of the thousands of soldiers—on the pavements on the table cloths."

Portrait of Berlin

Movements

approval. In October, Hartley was the only American in the largest avant-garde exhibition up to then in Berlin, the Erster deutscher Herbstsalon, five of his works hanging between groups by Kandinsky and Henri Rousseau. But then in November he was hauled kicking and screaming back to New York at the order of Stieglitz. Hartley could never understand why some rich person couldn't just sponsor him, since his wants were so few. Stieglitz, not the most mercenary of dealers, had to play the role of strict parent, reminding him that money was short and that he needed to make and keep up contacts in America if he was to sell anything. The trip and the exhibitions at 291 and elsewhere were moderately successful, both financially and psychologically, and Hartley fled back to Germany as fast as he could. Taking in London and Paris on the way, he was back in Berlin by the end of April.

The trip proved useful, however, in changing his art once again. He was reminded that he was an American in Berlin and could make that fact financially useful, a maneuver many an American in Europe has tried. In the summer after his return in 1914, he began trading on his origins by embarking on a series based on Native American objects and designs and entitled Amerika: "ideas and sensations upon the word America." This interest in ethnic and folk art, inspired in part by *Der Blaue Reiter* almanac, was to recur sporadically but persistently later in his career. *Indian Composition (Indian Tents, or Encampment)* and *Indian Fantasy*, both typical examples, used many of the same elements of earlier pictures—triangles, large curves, repetitive V patterns—but made them flat and decorative, as well as highly symmetrical. Some of the elements are faintly kitschy—the squatting Indian chief smoking the peace pipe, and the landscape of little teepees with fires in front of them—but that seems deliberate, in *Indian Fantasy*, as well. Hartley thought of the Indians as purer, more childlike, and a "completed" civilization, as he was to write: these paintings were records, not mystical investigations.

Then, on August 1, Germany began declaring war on the Allies. The tension had been building palpably for days, and the first reaction to the declaration in Germany was euphoria, one that Hartley identified with completely. This was to be a war which would cleanse Europe of degeneracy, and war was "the only modern religious ecstasy." He was infuriated at the "slanders" against Germany which he read in the foreign press, including the newspapers of supposedly neutral America, and decided to honor the young men who were marching off to "a horrible death" with a visionary series on Germany, to the "Himmel" and "Hölle" (Heaven and Hell) of the future. The Berlin Ante-War paintings used many of the same symbols as the Amerika series and other earlier works— the same lines, horses, trees, and so on. Both the Amerika and Berlin series paid homage to "completed" civilizations, one long gone and the other just about to die. But the horses and stars which had been simple paeans to glory in *The Warriors* or signs of the past in the Amerika works now become intensely elegiac. The pictorial space was gridded more distinctly, giving the paintings greater rigidity and making them more like the Bavarian folk paintings and woodcuts collected by Kandinsky and Marc. In *Berlin Ante-War* (page 62), the spaces below

Movements

1913. Oil on canvas, 47¼ x 47¼"
The Art Institute of Chicago, Alfred Stieglitz Collection, 1949

For Hartley, German life was "essentially mural . . . big lines and large masses—always a sense of the pageantry of living." The "large masses" in Movements may reflect the influence of Franz Marc and other Expressionists.

Indian Composition
(Indian Tents, or Encampment)

1914. Oil on canvas, 47⅛ x 47"
Vassar College Art Gallery, Poughkeepsie,
New York. Gift of Paul Rosenfeld

By August 1914, Hartley had completed
four paintings "on the idea of America."
He emphasized in this Amerika series,
as he called it, the childlike qualities he
perceived in Native American culture
by arranging objects in flat, primitive,
repetitive patterns.

Indian Fantasy

1914. Oil on canvas, 46⅝ x 39⅜″
North Carolina Museum of Art. Purchased with
funds from the State of North Carolina

Hartley's notion of Native American art, while based on the study of authentic artifacts in Berlin and Paris museums, relies on stereotypical souvenirs like teepees and canoes. Aimed at a German audience, it represents an entirely romantic idea—which was Hartley's point.

the cuirassier are divided up into little images of the ideal German countryside; in the center between them is a shrine with the veil drawn to reveal a sun and a cross. Above is a black horse, which rises to its mate, a white horse lying down in a globed landscape. It is a scene of a defender of the German soil rising to Valhalla—out of which Hartley has left the Valkyries (this is an entirely male vision). *Portrait Arrangement* shows a similar scene: the holy warrior, with his halo shining over his long blond hair, enters into a perfect little German heaven, a cottage shaded by two trees, one flowering and the other supporting nesting birds. Some pigs root in the earth of the German forest, abundant fish swim in the river, and birds fly in the sky, alongside the constellation of the Big Dipper and other stars. Typically, Hartley's vision grew more syncretic as he worked on the theme over time: *Painting No. 4 (Black Horse)* (page 64) seems to be a mystical union of lotuses, trees of life, teepees, and magic steeds: all his sources merged together into a universal whole.

Hartley's ability to adapt to the war changed forever when Rönnebeck was badly wounded, and far worse, Freyburg was killed in battle on October 7. Hartley was felled with despair: he felt "eternal grief," "unendurable agony," and called Freyburg's death "the most pathetic sacrifice of our time." In a dream shortly afterwards (which he addressed to Freyburg in one of his "Letters Never Sent")—a "classic dream in my experience since most of them are dreadful melanges of deranged sex images"—Hartley was crossing a field in a thunderstorm. Lightning struck a snake and a white light sprang up out of the coils, "up my entire right side." Then out of this light "there appeared a full-length image of yourself clad in full uniform but the uniform purged of all military significance was white." They smiled at each other: "It was the sublimation of our intended relation and was without blemish—and you were therefore in this dream immortalized." Given the silver shoulder straps from Freyburg's uniform and his Iron Cross medal by Rönnebeck, Hartley began obsessively working the elements of Freyburg's uniform into paintings, creating a series of moving, turbulent laments. Despite the dream in which Freyburg's uniform appeared blanched of the colors which would have identified specific regiments and honors, in the paintings Hartley worked with the "real" thing. In these memorials, a belief in the power of otherworldly vision was not strong enough; Hartley needed the power of his physical experience, located in the actual elements of Freyburg's and Rönnebeck's uniforms, to inspire him.

The centerpiece of the group is *Portrait of a German Officer* (page 59), Hartley's largest painting to that point. It presents the body of Freyburg—headless—as a battle trophy, larger than life: the breastplate or cuirass, defined by flags, becomes the shield behind which the tips of lances project. At lower left and right are a helmet with Freyburg's initials and tassels from the sash, placed to mimic the iliac crest of his hips; at the bottom and center, covering his genitals, is a red cross, with a spur from his boot next to it. And over his heart, on a triangular plate from which hang regimental tags, is the Iron Cross Freyburg won with his death; instead of a head, there is a circle cut in half. Behind this mournful array of things hides Hartley's memory of Karl von Freyburg, whom he never

Portrait Arrangement

1914. Oil on canvas with painted frame, 42½ x 34½" Museum Purchase, The McNay Art Museum, San Antonio, Texas

Before an idealized German cottage, set between pigs rooting under a forest tree and birds nesting in an orchard, under the sign of the Big Dipper, one of Hartley's favorite blond cuirassiers rises into a little Valhalla.

Portrait Arrangement

forgot as a "Man in perfect bloom/of six foot splendor/lusty manhood time—all made of youthful fire/and simplest desire."

The memorial to Freyburg grew into a series of paintings (*Military; Painting No. 47, Berlin; E. [German Officer Abstraction]*; pages 63, 65, and 66) all of which took elements of military life and turned them into an increasingly fragmented display. The parade of soldiers Hartley had painted the year before rising into the sun had now spiraled out of control, as though hit by a bomb. But as the months went by and he got his life back together again, he returned to the series he had begun before Freyburg's death, completing more Amerika and Berlin paintings with an eye towards an exhibition. The ambitious artist reasserted itself within him.

Hartley's summoning of his gay experience in the German Officer paintings is not tangential to the development of modern art. Like most forward-looking artists at the turn of the century, Hartley was dealing with the slow

Portrait of a German Officer

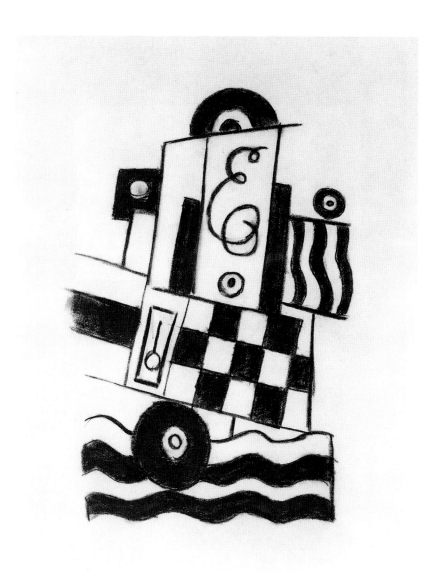

Military Symbols I

1914. Charcoal on paper, 24¼ x 18¼"
The Metropolitan Museum of Art, New York.
Rogers Fund, 1962 (62.15.1)

This drawing, an abstraction of a sleeve and epaulets of a uniform with a helmet placed adjacent to the top, makes clear the process by which the larger paintings were composed.

death of significance and meaning that seemed to have engulfed painting. Narrative, allegory, didacticism, morality, and heroic inspiration—all those things which high art had aimed at since the beginning of time were receding from the canvas in a melancholy, long grating roar. The dilemma for a modernist artist who clung to the idea that art was serious was to find the means to replace traditional modes. For Hartley, meaning in abstraction could be found in the way objects could be summoned to significance if the artist felt strongly enough, "quickening plain things into a state of true reality."[1] His approach was different from Symbolism, where the objects are seldom common and are often erotic or eroticized. Hartley drew on another tradition, that of empathy.

In the attempt to relocate the wellsprings of art outside religion or nature, that is, outside traditional sources of moral import and inspiration, empathy became a widespread and useful notion at the end of the nineteenth century. Empathy located the origins of aesthetic response in biological or experiential intuition, which rests within ourselves, rather than in an outside force (God or Nature). Essentially a Kantian notion, empathy posited that we respond to

"things," whether they be people, trees, or objects, because of their innate qualities and our mutual experience of gravity, smoothness, light, and so on. The empathic response was not dependent upon education, moral suasion, being led or governed by some outside force; it acted simply within, its operation articulated and analyzed as a series of natural or mystical operations. But however it worked, empathy involved the viewer's independent and unmediated response to "something" out there. As Bergson wrote, the artist must move "back within the object by a kind of sympathy in breaking down, by an effort of intuition, the barrier that space puts between him and his model." Unfortunately, much to the horror of most right-minded thinkers at the turn of the century, most of the "somethings" that surrounded people were shoddy manufactured goods. The dominant ideology behind the production of the sorts of things Hartley collected—his poetry and jewelry—was the Arts and Crafts movement. Part of the impulse behind the reforms of this movement, which did so much to change American design and which Hartley grew up with, was to cleanse the wells of empathic perception by filling the environment with just the right kind of objects to stimulate uplifting reactions. Arts and Crafts makers strove for pure objects which would promote purer thoughts.

Avant-garde artists used empathic association for other ends; they did not seek to reform mass-produced goods but accepted the inevitability of machines and machine production. They began the program of dealing with the things of a modern consumer's life with Cubism: Picasso's collages assembled the vulgar detritus of life in ways which forced his viewers to process them in all their messy reality. His innovations were carried further by many artists, but they generally limited themselves to the signs of life in the street—from cafés to advertising signs, packaging, shop windows—taking disorganized daily experience and reifying it. Hartley was an avid consumer and advocated window-shopping as therapy. He once wrote about Fifth Avenue: "If you wish to forget everything that gnaws at the flesh and bone during the day, then this is the antidote I would prescribe, which is to say, window shopping at night."[2] But Hartley's view of things on the street was freighted with the covert codes of gay subculture, where eyes held a fraction longer than polite, a flower in a buttonhole, a nickname or pronoun ("Marjorie" or "She," applied to unnamed men) signified untold depths.

Speaking of the ciphers he lived by in language reminiscent of Whitman's poetry, he told Stieglitz in 1911:

We have a language of signs—we who live close to the great soul of things—and we speak with symbols such as glances of the eye—touches of the hand—or the merest presence of another—these speak when words cling foolishly on the tongue—filling the mouth with foreign substance. And so there is but one policy for him who lives deep within himself. To live there in the depths of his own being—and from that registering artistically according with means chosen—his convictions. . . . And so the art of the man must be the art of himself only—the art which is the expression of his need, his specific and peculiar outpouring.

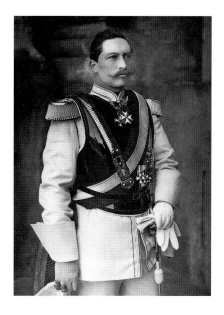

Kaiser Wilhelm II in a
cuirassier's uniform

c. 1880. Photograph.
The Hulton Deutsch Collection, London

*Karl von Freyburg was an officer of the
4th Regiment of the Kaiser's Guards,
whose uniforms were similar to the one
worn by the Kaiser.*

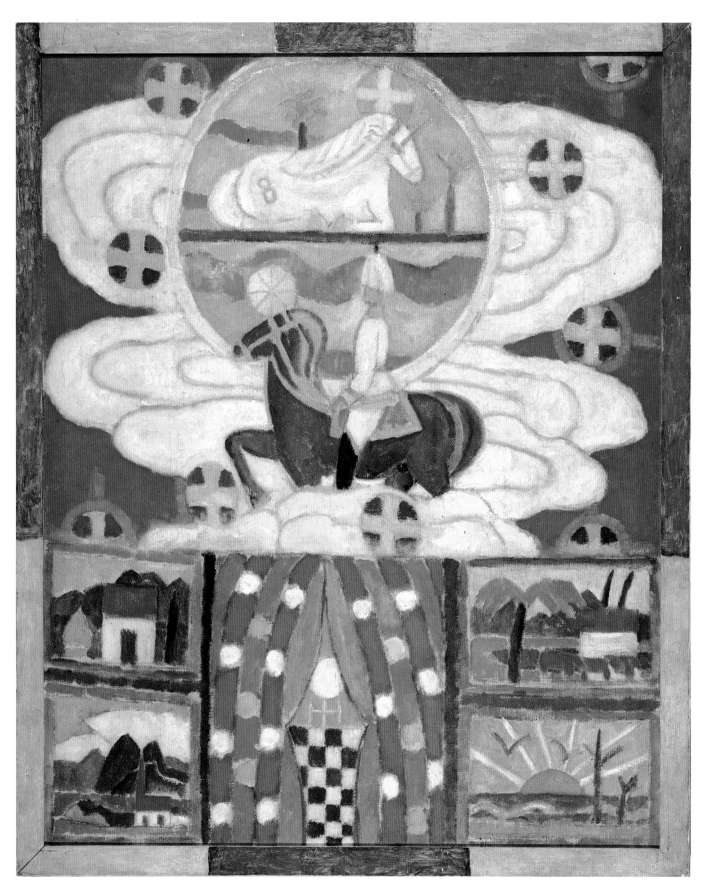

Berlin Ante-War

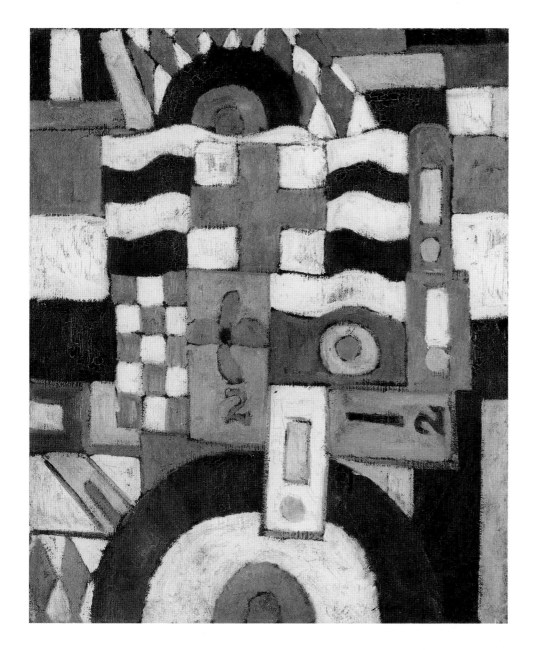

Military

1915. Oil on canvas, 28⅞ x 19¾"
The Cleveland Museum of Art, Ohio.
Gift of Professor Nelson Goodman

Hartley builds up this picture out of the epaulets and sleeves of the uniform, displayed against the usual background of flags and circles.

At the core of Hartley's sign system lay the "language of signs," the camouflaged life of gay experience.

In his military paintings, Hartley took an aspect of the most regimented and institutionalized expression of governmental power—the military uniform, the very thing that renders each individual man a standardized product of the state—and endowed it with private, erotic power. Carried to extremes—that is, generalized beyond the specific individual—this maneuver would be essentially fetishistic. Sexual fetishism, another aspect of the fascination with objects investigated for the first time only in the late nineteenth-century (by Krafft-Ebing and others), may be seen as the flip side of the Arts and Crafts movement, one welcoming and the other rejecting the enslaving power of objects. And Hartley certainly knew this aspect of life; he once wrote: "It was the smell of leather made a man of him. Stiffened his spine, gave him the orgiastic sense of

Berlin Ante-War

1914. Oil on canvas, 41¾ x 34½"
Columbus Museum of Art, Ohio.
Gift of Ferdinand Howald

The Berlin Ante-War series memorializes Germany before the onslaught of World War One. Hartley represents icons of a perfect, bucolic Germany, under the guardianship of his ideal soldier.

Painting No. 4 (Black Horse)

1914–15. Oil on canvas, 39½ x 32"
Philadelphia Museum of Art,
The Alfred Stieglitz Collection

While the teepee shape belongs to the Amerika series, the "8" on the horse is a symbol that Hartley associated closely with Germany (see caption page 50). By 1915, the series had merged into a universalized memorial for civilizations that had been destroyed by war.

Painting No. 47, Berlin

1914–15. Oil on canvas, 40 x 32"
Hirshhorn Museum and Sculpture Garden,
Smithsonian Institution, Washington, D.C.
Gift of Joseph H. Hirshhorn, 1972

This might almost be the head missing from the Portrait of a German Officer, *with a helmet set against a flag and the Iron Cross hanging below. But Karl von Freyburg's face is absent.*

being without which nothing happens, and with which all is as it should be. No one can get through anything being soft all the time."[3] Hartley's military paintings did not go this far; his longings were disciplined by abstraction. Nonetheless, his memorials to Freyburg plunder the heart of modern state power and eroticize and heroicize its strength, attempting to reclaim for private experience the person who had ultimately been destroyed by it. This artistic maneuver, growing out of the most harrowing private experience, is perhaps Hartley's greatest claim to enduring fame and perhaps his greatest success.

Hartley, in contrast to Kandinsky and Picasso each in his own way, could not forsake the comfortable tangibility of things; that is his strength. His paintings have a presentness and directness and weight which most other abstract(ing) artists of the day left behind. Hartley's feet were tethered to the world despite all of his attempts to transcend it. It is this great conflict—

Painting No. 47, Berlin

E. *(German Officer Abstraction)*

1914-15. Oil on canvas, 47⅛ x 47¼"
The University of Iowa Museum of Art, Iowa City.
Mark Ranney Memorial Fund

In the later German Officer paintings, Hartley abandons the image of Freyburg's body and manipulates the components of the uniform as flat decorative elements.

Himmel

1914. Oil on canvas 47⅜ x 47⅜"
The Nelson-Atkins Museum of Art, Kansas City, Missouri. Gift of the Friends of Art

Himmel *should be called "Himmel und Hölle" ("Heaven and Hell") since both words appear in the painting. It includes another defender of the German heritage, an old statue of a mounted ruler.*

between the fierce desire to achieve mystical union with the beyond, with light and purity, as far away from the sordid lusts of his physical life as he could get, and his equally strong attachment to the delectation and consumption of goods (cigarette cases, flowers, rings . . . boys and sailors)—that drove his life and art. No wonder he was almost unbearable company: who could not have sensed the strain between his genuine spirituality and epicene tastes and not read Hartley as insincere? No wonder too that the possibility of uniting his warring selves in the love of, first, Karl von Freyburg and, then, Alty Mason in the 1930s were such burning, transforming experiences. In his love for them, his physical and spiritual life could be united, a union not to be tested by experience but sealed by death. Out of that union came his greatest art.

But the moment in Berlin was not to last. It became increasingly complicated to get money from America and impossible to sell anything in Germany; simply being a foreigner there was becoming difficult. He hung on as long as he could, convinced that he was doing the right thing for his career. He had one last triumphant exhibition in Berlin, with forty-five paintings at the Münchener Graphik-Verlag. And then he was forced to leave, never to return to Berlin and Germany as they had been.

Himmel

One Portrait of One Woman

V. Home Again, 1916–21

Hartley returned emotionally frozen and deeply depressed to a land to which he had cut nearly all ties. His parents were gone (his father had died in August of 1914 and his stepmother the following May)—and his family refused to understand why he had not come back at their deaths. In addition, his career was crashing down around his ears. Typical of his missteps and wrong turns was his visit with Mabel Dodge, the society patron of his dreams. She had invited him to stay in her villa in Florence, but she had abandoned Europe because of the war before he had had the chance. Now he found himself on her estate in Croton-on-Hudson, which was not the same thing at all, and his moping got on her nerves. Furthermore, his German military paintings—into which he had poured his love and grief—were roundly criticized: in a country rapidly mobilizing to join the Allies, Hartley had fatally chosen the wrong side.

Hartley had lost his bearings, and he had to reinvent himself and his art, quickly. After recovering from the shock of reentry, for the next five years he traveled from one place to another and changed his mode and manner to match. The events brought on by the war—the death of Freyburg and the destruction of his budding European career—seemed to have proved to him that painting was no repository for his deepest emotions: the world betrayed them at every turn. For the time being, art would be distanced from his heart: "I want my work in both writing and painting to have that special coolness, for I weary of emotional excitement in art, weary of episode, of legend and of special histories."[1] In severing the link between art and his emotions, he turned from abstraction as did many other artists. For the next few years he stumbled through settings and styles in search of stability and hope, returning in the end to the last work he had done in Paris before diving into abstraction and mysticism.

One of his first completed paintings after his return announced some of the themes he would pursue in the next few years. *One Portrait of One Woman* is a portrait of Gertrude Stein, Hartley's claim to have known Stein better than had all the other expatriates floating around New York. While the painting is full of visual reminiscences of his Berlin work, the tablecloth and teacup bring Hartley back from the fragmented references of those more abstract works. The teacup calls to mind Stein's salon and the teas Hartley had with her, talismans of his sophisticated life in Europe; yet the painting also contains the elements of a very traditional still life, a subject he had abandoned soon after leaving New York in 1912.

One Portrait of One Woman

c. 1916. Oil on composition board, 30 x 25″
Bequest of Hudson Walker from the Ione and
Hudson Walker Collection, Frederick R. Weisman
Art Museum, University of Minnesota, Minneapolis

A portrait of Gertrude Stein, the painting complements her verbal portrait of Hartley in her play "IIIIIIIIII." Hartley imitates Stein's verbal wit: "moi" means "I." "One" also refers to oneself, when speaking grandly in the third person; and one in Roman numerals is "I."

Provincetown

Still Life No. 9

1917. Oil on beaverboard, 24 x 20″
Bequest of Hudson Walker from the Ione and
Hudson Walker Collection, Frederick R. Weisman
Art Museum, University of Minnesota, Minneapolis

*Calla lilies were a favorite subject for
Hartley, until Georgia O'Keeffe made
them famous. Afterwards, Hartley, envi-
ous, refused to use them.*

But Hartley was not yet ready to give up abstraction entirely. In Province-
town that summer—the summer that the Provincetown Players were formed—
Hartley roomed as a guest with John Reed, the radical journalist (although
Reed later confessed to employing stratagems to get Hartley to leave the house),
but seems to have ignored most of the shenanigans around him. Instead he con-
centrated on new pictorial solutions. He continued to paint both still lifes and
abstract groupings of real-world elements (boats rather than uniforms, but still
just parts of a whole), but now subjected them to a rigorous pruning of color
and energy. These abstract paintings cohere in the center of the composition,
rather than fly about decoratively over the entire surface; the still lifes are
faceted but flattened, pinned like butterfly wings to the canvas. Now Hartley
pays attention to the surface with new concentration, producing quietly charm-
ing works which are almost monochromatic.

A ritual he began soon after returning to America underscores the fragility
of this serenity, however: he would go to the American Museum of Natural His-
tory in New York and place his hand on the Willamette meteorite in the
entrance hall, making "contact with major elements," as he put it.[2] The physical
remains of this otherworldly catastrophic fireball brought him back for a brief
moment to his own hapless, fiery passage.

The strain of the effort to forget the past may be felt in *Still Life No. 9*, where
the leaves writhe despite the way they are captured in flat, prismatic facets. One

Provincetown

1916. Oil on composition board, 24⅛ x 20″
The Art Institute of Chicago,
Alfred Stieglitz Collection, 1949

*Formed by the same process of abstrac-
tion as his German Officer paintings,
this painting displays the restrained col-
ors and background that are intended to
mute any sense of energy: they are delib-
erately therapeutic.*

Abstraction

1916. Oil on board, 24 x 20"
Present whereabouts unknown

Hartley's stable building up of boat forms is the antithesis of his European abstractions. The boat is probably the Elsa Kobenhavn, *seen in several other paintings.*

Movement, Provincetown

1916. Oil on board, 20 x 16"
Photograph: Courtesy Salander O'Reilly
Galleries, New York

This belongs to a series of paintings of cocktails and drinks, wineglasses and flowers, reminiscent of café life in Europe, transferred to America.

may also doubt Hartley's self-alleged "coolness." In the boat paintings, such as *Abstraction*, Hartley was returning to the scene of one of his first loves—ships and sailors. One particular boat was the subject of several works, a Danish ship, *Elsa*, from Copenhagen, which was filled, no doubt, with blond sailors. Many of the still lifes, paintings of martinis and cocktails, conjure up a Manhattan café life as an attempted replacement for the sophistication of French cafés, in a style which reworks Synthetic Cubism. All these works are an attempt by Hartley to reintegrate his work into his life, and yet avoid the awful issue of love.

Hartley's closest friend in Provincetown was Charles Demuth, another gay artist, whom he had first met in Paris. At the end of the summer, after Reed left, Hartley and Demuth decided to stay for a few more months. As winter closed in, and the return to New York grew closer and more distasteful, they decided to head farther south, to Bermuda. There, the unreal world of these decorative still lifes could continue unabated. After a few weeks in New York, Hartley sailed for the sun, with Demuth following him a short time later. Hartley stayed until May, not doing anything in particular it seems, and soon afflicted by boredom.

The one motif which he experimented with in Bermuda—the still life in front of a window (which had been popularized by the Fauves a decade before)—would be the only thing to stay with him. *Atlantic Window in a New*

Movement, Provincetown

Atlantic Window in a New England Character

Still Life with Eel

1917. Oil on canvas, 30 x 25"
The Ogunquit Museum of American Art
Permanent Collection, Maine

The overtly sexual references in this still life—the writhing eel and luscious red amaranth—suggest a reference to Hartley's private life—a self-portrait of his Bermuda experience.

England Character, an abstract self-portrait, is representative; what is also typical is the banana lying on the table with the calla lily. By this time, as several critics noted, these objects had been clearly sexualized. His friend Paul Rosenfeld commented that these still lifes "referred the universe to the human body and felt the human body in the objects present to the senses. As men have done in all baroque ages . . . Hartley too, in his, stresses in what he shapes the sexual interests of the mind . . . via the large cucumbers, bananas, pears, goblets, lilies, and rubber-plants in his compositions."[3] *Still Life with Eel*, with its winding, phallic eel, seems to be another portrait-like accumulation of objects. Both paintings are images of his life in Bermuda: what Hartley and Demuth seem to have done most was sun themselves and pick up soldiers.

But the lack of paintable motifs—Hartley reduced his vision of Bermuda to what he could see between the curtains of his hotel window—soon drove him to distraction, and he welcomed the return to New York. That summer, instead of going to Provincetown (he had worn out his welcome with Reed), he landed a spot at the art colony founded and supported by the wealthy amateur Hamilton Easter Field in Ogunquit, Maine. This was a timid step over the border into Maine, one he was not to repeat for many years.

Field was an early promoter and collector of American folk art (a passion

*Atlantic Window in a
New England Character*

1917. Oil on board, 32 x 26"
Collection of Harvey and Françoise Rambach.
Photograph: Courtesy Salander-O'Reilly Galleries, New York

"This regal white lily with its wickedly horned leaves, erect between butter-yellow draperies, is felt as a volume against that lustrous purplish-blue sweep of bay, as that is felt against the curve of sandy shore, and the shore in turn felt against the rim of violet peaks and they against the white-clouded summer sky."—Paul Rosenfeld, Port of New York

Anthurium in Vase

1917. Oil on glass, 21½ x 10¾"
Courtesy Hirschl and Adler Galleries, New York

Hartley's glass paintings used many of the still-life motifs he had developed in earlier works.

which can also be seen in the work of many Ogunquit protégés). In response, Hartley revived his folk art interests, originally stimulated by *Der Blaue Reiter* and his *Amerika* subjects. Encouraged by Stieglitz to "do Americana," Hartley too began to experiment with naïve American subjects.[4] He began to paint on glass, a folk technique which had been popular in Bavaria; examples of it had been collected by artists like Marc and Kandinsky (who owned hundreds). But Hartley looked specifically at "saloons and shop signs," that is, at American manifestations of the same impulse. All of the glass paintings consisted of severely plain and symmetrical vases and bowls of flowers and fruits. They relocated his Provincetown still lifes of the year before in a nineteenth-century American context; he was one of the first to be interested in Victoriana, a taste which would grow quickly after the war. He suggested to Stieglitz that his glass paintings should be sold at Wanamaker's department store in Philadelphia: "It is the time to get it while that spirit is on, that is to say, while the victorian emotion is passing." All aspects of American popular culture, both past and present, enthralled him, from circuses to movies, from Nordica, the opera singer, to the film comedians Laurel and Hardy. However, as his movie buddy Helen Stein remembered, if the movie star was particularly handsome (like Douglas Montgomery, a particular favorite), he would go many times by himself. The principal attraction of circuses, just like the movies, was "the superb arabesque of the beautiful human body that I care for most."[5]

The logical next step towards reclaiming America's genuine past was to go to the Southwest to observe living Native American cultures, a trip many contemporaries also made. Hartley arrived in New Mexico in the middle of June 1919, and stayed in the West for over a year. As always his first reactions were ecstatic. He stayed in Taos first, to be near Mabel Dodge; but after a few months headed for Santa Fe, where it was purer (and cheaper). Then the cold and the isolation got to him, and he hightailed it to southern California in February, returning only at the end of June.

Hartley's artistic reactions to New Mexico were inconclusive. Two areas of authentic primitive life—something he had been interested in since his first days in Paris (see page 37)—lay ready for examination, Hispanic and Native American. However, his attempts to apprehend them artistically were incomplete. In a group of paintings of *santos*, religious sculptures and paintings, he accumulated the resonant objects of Hispanic life, but the paintings were nothing more than still lifes, however skillfully and beautifully presented. Indians both amazed and repelled him, and he could assimilate them only in words, producing essays for *The Dial* and other publications: America was not the same thing as *Amerika* and his eyes could not see past its surface. He concluded his essay on "Tribal Aesthetics" with the lament that "We are without the power to celebrate the simple experience. We have no ceremony for our vision." His own paintings acknowledge the weakness, betraying the fact that he had no ritual framework to work with in front of the Native American reality.

Hartley bravely told himself that the truth lay in the land, but here again his reaction was less than inspired. His attempt to learn the landscape slowly, before

Vase of Flowers

1917. Oil on glass, 13¼ x 8⅞"
Carl Van Vechten Art Gallery, Fisk University, Nashville, Tennessee

Hartley claimed that he painted on glass in imitation of Victorian saloon signs. Here his relationship to Bavarian glass painting and folk art is clearer.

he moved on to a deeper vision, only betrayed the fact that he really felt nothing for it—as is evident in *New Mexico Landscape* (page 80, top). He started by drawing pastels "to get my hand in, copying nature as faithfully as possible, and they are turning out well having all that I used to have, plus a certain something that has come to me out of six years devotion to abstraction." A few images resonated with memories of the deserted farmhouses of Maine, but for the most part his transcriptions of the hills were flat. Not until he was safe in his New York studio, in December 1919, could he monumentalize the memory of the New Mexico landscape and start producing visions of hills and foothills mounded like loaves of bread. Here the raw data of sensation or reaction have been processed into larger, slower forms, suitable as an impressive public statement by one of the first modern artists to come back to New York with impressions of the Southwest.

But back in New York, aside from the few New Mexico landscapes, his subjects settled back into still lifes, all more or less of the same sort: a single, centered vase or pot with a plant against a curtain. Now he painted them even more consciously in a Cubist fashion, the early Cubism of more than decade before, the style he had used in Paris that first summer, before he discovered the mystical appeal of abstraction. Although technically accomplished, they suggest that Hartley was seriously adrift.

Socially, he could comfortably feel he was at the center of things. Katherine Dreier had appointed him first secretary of the Société Anonyme and he was invited to join in New York Dada activities, even writing Dada poetry. He recalled the New York Dada group, "under the prussian direction of Katherine Dreier, who having female fits about Marcel, wanted to be on top herself . . . and the thing was really fun, and funny, because we met once a week at Mary Knoblock's house for lunch, and Mary was then rich and did she have food, well . . . not a damn word was mentioned about dadaism or anything else much that I recall but the weather and the food."[6] Hartley's poems were accepted by *The Dial*, and in the spring of 1921 his first book, *Adventures in the Arts*, was published to good reviews. To a great degree, the intellectual and artistic life he had witnessed in Paris and had tried to join in Berlin was now his. But it was hollow. Or perhaps he now thought his fame was secure and believed his own press, little realizing how thin this intellectual efflorescence was. Having arrived, he wanted out.

Hartley began to hound Stieglitz to find a way to send him back to Europe. He was desperate to return, and when no wealthy angel deigned to rescue him, he took matters into his own hands. He persuaded the unwilling Stieglitz to arrange for an auction of one hundred seventeen of Hartley's paintings and drawings at the Anderson Galleries in May 1921—which raised nearly four thousand dollars, an unheard-of sum, as all the papers noted. While part of the reason for returning to Europe was his desire for a more rewarding personal life—in other words, the hope of forming some sort of relationship or, at least, to live in a world where the disparate parts of his personality could be more easily accommodated—Hartley also knew that he had to return for artistic reasons.

Santos, New Mexico

c. 1918–19. Oil on composition board, 31¾ x 23¾"
Bequest of Hudson Walker from the Ione and Hudson Walker Collection, Frederick R. Weisman Art Museum, University of Minnesota, Minneapolis

Santos *are small Hispanic religious paintings or statues, collected avidly by Easterners searching for authentic folk art. Mabel Dodge Luhan had many in her house in Taos, where Hartley painted: the large hand and figure in the background may be hers.*

Santos, New Mexico

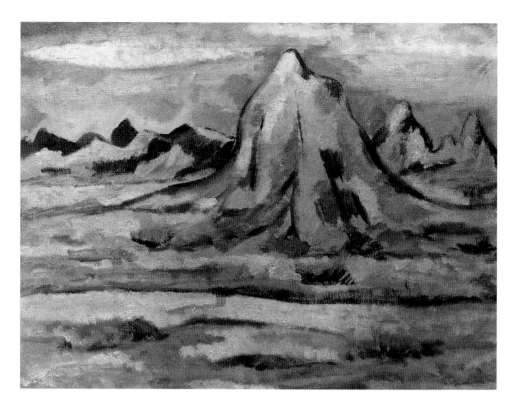

New Mexico Landscape

1919. Oil on canvas. 18⅛ x 24⅛″
Bequest of Hudson Walker from the Ione and
Hudson Walker Collection, Frederick R. Weisman
Art Museum, University of Minnesota, Minneapolis

Hartley spent much of his time in the Southwest struggling to capture in a straightforward manner "the magnificence and austerity" of the landscape.

New Mexico Landscape
(with Deserted Farm)

1918–19. Pastel on paper, 17½ x 28″
Private collection

Wherever he traveled, Hartley tended to discover the same motifs. The deserted farm is an image of desolation that endures throughout his career.

Despite the confidence and quality of his New Mexican landscapes and the series of still lifes done in a *retardataire* Cubist manner, Hartley must have known that the work was not inspired. He had seen too many of his contemporaries return from Europe and become boring hacks. He probably knew as well that to return at this point of his career would hurt it with American collectors, however much he may have told himself that his reputation was secure enough to withstand a long-term absence. But he also knew that to stay would mean his artistic and spiritual death. In July he sailed for Europe.

New Mexico Landscape

1919. Oil on canvas, 30 x 36"
Philadelphia Museum of Art,
The Alfred Stieglitz Collection

Returning to New York, Hartley trans-
formed his initial impressions into larg-
er, more considered, and monumental
landscapes, favoring the density and
sense of bulk that had marked many of
his Maine landscapes.

Pears in White Compote

VI. Wanderjahre, *1921–31*

FOR THE FIRST TIME IN HIS CAREER Hartley felt financially secure. The four thousand dollars from the auction was the largest sum of money he had ever seen in his life, and in 1924 he arranged with a syndicate of four bankers to subsidize his living expenses in return for paintings over the span of four years. This longed-for security, however, did nothing for him: neither his life nor his art settled into a pattern; both seemed to drift aimlessly. He could claim to his niece that: "It isn't the fame I must have you all know, it's the satisfaction of knowing that what started right is finishing right and if I don't quite fill the bill as a good member of a family, the world has taken me in." But it really wasn't so.

Hartley's first impulse was to kick up his heels a little, which he did very capably in Berlin where the hyperinflation after the war made American dollars go far. Hartley, for the first time, gave in fully to his fancies. Rönnebeck remembered Hartley inviting him for tea so that they could both admire a ring in Cartier's window. Three days later Hartley sported it on his finger: "I couldn't stand it always just *looking* at the damned thing any longer." In fact, nothing needed to be just looked at; everything could be had. Robert McAlmon, with whom Hartley shared many a nightclub adventure, used this experience in a short story, "Distinguished Air," in which Hartley appeared as Carroll Timmons, a prim New Englander of "elderly aunt-like visage." Seated in a disreputable club with a boy on his knee, Timmons proclaimed: "When there are such lovely window displays to see in the shops I can't be bothered by people who bore me. . . . There are so many beautiful young things in the world." Hartley, in Timmons's voice, admitted: "So foolish of me, and how often I have been disillusioned, but after New England, all that absurd moral bugaboo pursuing me for so many years, and then the snap, and the feeling of release within myself." Hartley's own stories of Berlin—for it seemed everyone tried his hand at describing the spectacle of the world's greatest modern city, the pinnacle of orderliness and technology, traumatized by defeat, exhaustion, and poverty—revealed his fascination and distress at the sight. One described a ring of cannibals, another a pair of women who kill their abusive husbands, fall in love, and are freed to live together—a sadly touching story of homosexual love formed in a crucible of hate but gently permitted to live on.

Hartley's art, on the surface, seemed to have nothing to do with the life he was leading. With an eye on his American market, as well as his sense of being an American in Berlin, he did not paint the life of Berlin—that was his private experience, segregated from the art the world could see, to be shared, if at all, only in the persona of author not painter. Instead, he continued to work on still lifes and his New Mexican landscapes, now firmly entitled "New Mexico Recol-

Pears in White Compote

1923. Oil on canvas, 21¼ x 25⅝″
Bequest of Hudson Walker from the Ione and Hudson Walker Collection, Frederick R. Weisman Art Museum, University of Minnesota, Minneapolis

Hartley's still lifes in the early 1920s show the influence of Georges Braque and Juan Gris in their suave elaboration of flattened shapes. This compote appears in several works, including lithographs he published in 1923.

83

Landscape, New Mexico

1923. Oil on canvas, 21¾ x 35¾"
Collection The Equitable Life Assurance Society
of the United States

Continuing to paint New Mexico land-scapes in Berlin, Hartley made them even more abstract. The plant forms in the foreground reveal his reliance on small potted cacti to prompt his memory.

lections." The still lifes, such as *Pears in White Compote*, were influenced by Braque and not Picasso (whom he seems to have given up on); but the land-scapes have little to do with New Mexico. *Landscape, New Mexico*, like the others, was modeled on "a lot of very broken down cactus plants," in the dyspeptic words of one acquaintance. Under the surface, more disturbing signs lurked. The fleshy protuberances and sense of constipation and excretion speak of Hartley's sex life. At the same time, they deliberately recall the "dark land-scapes" of his first encounter with Ryder. They reveal the simultaneous and unendurable (for long) pull between real facts and transcendental longings.

Hartley tried finally to face the source of his pleasure and repulsion direct-ly in a group of pastels done in the summer of 1923. That is, he depicted the male nude, the first time he had confronted the human figure since art school. At the same time, he was trying to break out of still lifes into the new market for neoclassical figures (Picasso having led the way a few years before). There is a lurking sense of eroticism about the heavy powerful blond body of the wrestler, however, which Hartley perhaps felt too dangerous. He found a female model later to try and balance things, but the drawings of her have little of the same energy. Although he produced a few paintings based on the pastels (again mod-eled on Braque), Hartley would not repeat the experiment for fifteen years.

After finishing the nude studies, Hartley went off to Italy to visit the Renais-

Seated Male Nude

1923. Sanguine pastel, 24 x 17"
Courtesy Babcock Galleries, New York

*In July 1923, Hartley began to draw the
nude figure again for the first time since
1905. His model, a twenty-two-year-old
former wrestler, because of the heat "can
pose nude without distress to me or said
model," he told Stieglitz.*

Standing Male Nude

1923. Pastel on watercolor paper, 23⅜ x 16⅛"
Bequest of Hudson Walker from the Ione and
Hudson Walker Collection, Frederick R. Weisman
Art Museum, University of Minnesota, Minneapolis

sance masters and their classic figures. It was a diversionary feint on his part, despite his deep admiration for Masaccio and Piero della Francesca. After two months in Florence and a few weeks in Rome, he sailed back to New York to replenish his finances by establishing the arrangement with the bankers. A few months in the United States proved more than enough and he was back in Europe by June. But Hartley did not go back to Berlin: that had proved too debilitating, both physically and emotionally. And besides, it was getting expensive again.

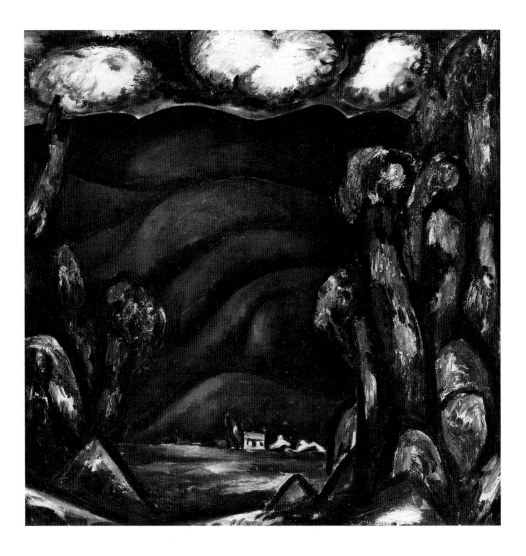

Paysage

1924. Oil on canvas, 31⁷⁄₈ x 31⁷⁄₈"
New York University Art Collection,
Grey Art Gallery and Study Center,
Gift of Leo M. Rogers, 1972

*Hartley described this work as a "large
rearrangement of the Maine landscapes
of former years." He declared to Stieglitz
in 1929 that Maine "is the country that
taught me how to endure pain."*

Everything was up for grabs—both what and where to paint. Hartley seems
to have realized that he really couldn't remake his style from the ground up, that
he could not become a figure painter or abandon the modernism in which he
had invested so much of himself. It was clear that the brave world of the spirit
that Kandinsky and Marc had tried to establish in Germany had been irretriev-
ably destroyed by the war. German painters now were "too full of eroticism and
symbolism and naturally, more than ever disguised under cubistic angularity.
. . . Nothing I have seen indicates personal perception and approach. . . . I
wonder if the Germans will ever learn to leave out their private lives from their
pictures."[1] Hartley's condemnation smacks of the pot calling the kettle black,
but the problem was a real one: how to come to terms with the postwar situation
when idealism seemed dead and all alternatives slowly degrading.

Hartley went back to the beginning again: to Paris. And to Cézanne, whom
he had discovered just before going to Paris the first time, as a guide to lead him
out of the wilderness as he had done before. But his first works in Paris retreat-
ed even further, to the "dark landscapes" of 1909, which he now reworked on a
larger scale, as in *Paysage*. The first "dark landscapes" had been produced dur-
ing a suicidal depression; the later ones must record similarly dark feelings. The

feeling of homelessness which these paintings reveal afflicted Hartley at several fundamental levels, in both the realities of finding a place to settle and the need for relationships, and finally in the question of where to place himself as an artist.

First of all, he wanted a home of his own. "I want so earnestly a place to be . . . a little house somewhere so that I can fulfill the common domestic needs of my nature, a place in which to really organize and systematize the rest of my life. . . . I'm tired of living in one room all my life—I want the expansion that comes from opening and shutting my own door."[2] Then he wanted love. Some gay friends from Berlin had gotten married. To a friend from those days, Donald Greason, he later wrote: "As for you, you have known what it was and have turned away from it and that's a very decent thing. I have another boyfriend [who married, had two children, remarried a rich woman, left her, and was now digging ditches again]. . . . He came to see me off on the boat for Mexico last year and said he was trying for a light house keeper's job—so superbly symbolic. So men have to find their own way out, if they care, and they usually do."[3] But that way out was not imaginable for him; Hartley got a cocker spaniel instead. Love as a subject and source for his art was just not possible. It is no surprise that, at the end of six years in Europe, he could write to Rebecca Strand (Paul's wife): "It is the consuming ambition of my life now to remove all trace of 'inwardness,' to have the image revealed as an immediate experience and not by thought or reflective process."

Hartley did find a home, temporarily, but not in Paris. After a year there, he needed another change. He went to the country, to Vence in the south of France. Again he complained of dullness and fatigue, most of it quite genuine as a lingering bronchitis slowed him down. He had not completed the required number of paintings for the bankers' syndicate, and he was dissatisfied with them and the landscape around him. Yet his views of Vence, such as *Landscape, Vence,* are compellingly accomplished. They look rather like the work of his contemporary Leon Kroll; as solid and deliberately unimaginative but with more presence. Cézanne has congealed into impassive inertness here, but very impressively.

Having signed a year's lease on a house in Vence, Hartley was eager to escape as soon as possible. Free in October 1926, he went straight to Aix-en-Provence, only a few hours away, and rented a studio in Cézanne country, quickly making a small circle of friends, which included Adelaide Kuntz, who was to become one of his strongest supporters. In the new year, he moved into the Maison Maria, which had once served Cézanne as a studio. Provence, he claimed, was "the first spot on earth where I have felt right—in harmony—body, soul and mind—and if that can't be called a state of 'home' then nothing can."

But such closeness to Cézanne proved almost deadly. Hartley's work turned into delightful, suave reminiscences of Cézanne's Mont Sainte-Victoire and his other scenes, compositions, and brushstrokes: beautiful and meaningless. Hartley was ready to escape before long. He had turned fifty and seemed to have arrived at a dead end.

Trees and Wall

c. 1927. Pencil on paper, 10 x 8¾"
Bates College, Museum of Art, Olin Arts Center, Lewiston, Maine. Marsden Hartley Memorial Collection, 1955.1.17

In a series of beautifully finished silverpoint and pencil drawings, Hartley adapted Cézanne's motifs and style to his own preoccupations.

Landscape, Vence

1925–26. Oil on canvas, 25⅝ x 31⅞"
Bequest of Hudson Walker from the Ione and
Hudson Walker Collection, Frederick R. Weisman
Art Museum, University of Minnesota, Minneapolis

Hartley stayed in Vence, above the Ri-
viera, for a year, producing several large,
highly finished views of the landscape.
Most of his painting, however, was
devoted to still lifes.

Mountains in Stone, Dogtown

1931. Oil on board, 18 x 24″
Collection of Harvey and Françoise Rambach.
Photograph: Courtesy Salander-O'Reilly
Galleries, New York

"The place is forsaken and majestically lovely as if nature had at last formed one spot where she can live for herself alone. [It] looks like a cross between Easter Island and Stonehenge—essentially druidic in its appearance."
—Hartley, *"Somehow a Past"*

Two Shells

1928. Oil on canvas, 19¾ x 24"
Hirshhorn Museum and Sculpture Garden,
Smithsonian Institution, Washington, D.C.
Gift of Joseph H. Hirshhorn, 1966

At the end of 1928, after a long break from painting, he began work again with a group of studies of seashells. The intensity of his concentration presages his later paintings of beach debris.

For the next few years, he tried to make the house in Aix work, but after a few months he would always have to visit the city (although the regular jaunts to the baths and alleys of Marseilles proved insufficient). A trip to New York to supervise an exhibition proved draining and unnerving, and he railed against his dilemma: he felt a deep need to conceal his life but knew that his art suffered for it. He proclaimed in an essay entitled "Art—and the Personal Life" in 1928: "I am interested then only in the problem of painting . . . and not at all in private extraversions or introversions of specific individuals . . . I no longer believe in the imagination. I rose one certain day—and the whole thing had become changed. I had changed old clothes for new ones, and I couldn't bear the sight of the old garments. . . . I had rather be intellectually right than emotionally exuberant, and I could say this of any other aspect of my personal experience."

Then for almost a year he ceased to paint. When he finally picked up his brush, it was to make small still lifes of shells, simple, beautiful things painted in pleasing colors isolated against bright backgrounds: the thing itself, seen almost compositionless and unstructured, such as *Two Shells*. These finger exercises announce his monumental late style on a small, decorative, almost unnoticeable note.

Back in New York, however, his first exhibition of his Mont Sainte-Victoire views, his first solo exhibition in Stieglitz's reconstituted gallery (four years after the gallery had opened) was a decided failure. Both Stieglitz and he agreed it was time to come home. When his lease on the Maison Maria expired in Novem-

ber 1929, he returned to New York—after a three-month detour through his favorite fleshpots, as though to stock up before leaving.

On returning to America, he finally did what he had been told to do for years: he went home to Maine to paint it again. Or as close as he could comfortably get, to New Hampshire, on the other side of the hills he had painted in the teens. His first response was as wildly optimistic as always, as he willed himself to love what he had to do. The paintings betray him, however: they are dark versions of his Mont Sainte-Victoire paintings, with no life to them at all.

Very quickly the reality of his situation threw him into a deep depression. He was stuck in a remote, rundown farmhouse, just as he had been in North Lovell, as though the twenty years of Europe and all his experiences and reputation had been a mirage. He hung on by sheer willpower until November to paint the autumn colors and then went back to New York to be desperately ill with bronchitis for two months, confined to his bed and dependent on friends to bring him food. He declared to Rebecca Strand: "I've learned one thing— never never never turn north again as long as I live." The New Hampshire paintings were received reasonably well—that was the surprisingly good news; the bad was that his ears were examined and his mastoids were so scarred that his doctor thought his life hung by a thread. He was given only a few years to live.

Against such danger, Hartley rallied as always. After eight months without painting, he went to Gloucester for the summer to the artists' colony he had visited in 1920. There he stumbled onto a new motif which would point the way to the future, one he had seen on his first visit but had not painted: a stark landscape of large glacial boulders, Dogtown Commons, seen in *Mountains in Stone, Dogtown*. The Dogtown paintings had the same kind of aimless composition and physical presence as the shell still lifes he had painted in Paris in 1928. The boulders were of course heavier and colder than the shells, but they had the same sense of thingness to them, and sense of mystery. More importantly, the paintings were completed from memory, as it proved too cumbersome to bring his painting materials to the site. The exhibition of the paintings, which opened in April 1932, after he had left for Mexico, was announced with his poem "The Return of the Native": "He who finds will/to come home/will surely find old faith/made new again,/and lavish welcome."

The new energy and optimism which contributed to the strength of the Dogtown pictures derived in part from his knowledge that he had won a Guggenheim travel grant, which would support him for a year so long as he spent it outside the country. No sooner had the "Native" returned to his chosen north than he was eager to leave, for sunshine and warmth, for Mexico. His first entirely successful subjects in a decade he would abandon for three years.

Tollan, Aztec Legend

VII. Mexican Interlude, 1932

Hartley arrived in Mexico City in March 1932, ready to immerse himself in an exotic culture and climate. His first two months he spent at the National Museum looking at Aztec and Maya art. His initial impulse was generous: this was to be a repetition of the adventure of 1916 out in the Southwest. Very quickly his enthusiasm turned to bitter disappointment. Hartley could find no connection between the native past—the Aztec and the Maya—and Mexico's present hybrid Spanishness. The foreclosing of the pre-Columbian cultures seemed to him Mexico's great tragedy. Ironically, in trying to re-create his New Mexico experience—which had played so important a part in establishing him realistically on the ground (stylistically speaking)—he would find in Mexico its antithesis, discovering a way back to the mysticism of Berlin.

Mexico, he declared, "devitalized my energies, the one place I always shall think of as wrong for me." For one thing, the altitude caused him constant difficulty; he felt as if his "chest would actually crack open from pressure."[1] Moreover, tellingly, for a being as sociable as Hartley, he made only one Mexican friend (he spoke no Spanish) and had to rely on the interesting, but very small American community.

One thing saved him: the use of Mary and Eric Ostlund's occult library. There he immersed himself in mystical literature, which he had not done in over a decade, not since Karl von Freyburg's death, prompted perhaps by another death, the poet Hart Crane's. Crane, another Clevelander whom Hartley had known slightly in Europe and Brooklyn, was also on a Guggenheim. The two had the chance for a few heart-to-heart talks, and although Hartley doesn't speak of it, the warmth of emotion with which he recorded the visits and his protestations that he had had the ability to help Crane, suggest that one of the topics they discussed was their homosexuality. Hartley felt that he had made a real connection with a poet and young man he admired. But on his return voyage home to the United States at the end of April, Crane jumped overboard and drowned, a willful suicide which struck at Hartley's sense of his own life and destiny and caused him to rethink things. The dislocation of Mexico, with its entirely foreign past and unpleasant present, reinforced the isolation.

This short period of work in Mexico was profoundly important, completing the work begun in Dogtown. Never again would Hartley lose his way as he had those last years in France. The connection he made with his mystical roots through the death of a male friend would serve him unconsciously for the rest of his life. While he would seldom again so straightforwardly make mystical

Tollan, Aztec Legend

1933. Oil on canvas, 31½ x 39¼"
The Regis Collection, Minneapolis

This is the first of Hartley's paintings for an "Arcane Library." It represents an Aztec legend of a white bird: "From the dreadful north, House of Fear in Mexico, descends ITZLI, god of death and the stone knife of sacrifice."

93

Carnelian Country

1932. Oil on board, 23⅞ x 28¾"
The Regis Collection, Minneapolis

In his Mexican landscapes, Hartley returned to the motifs of his first New Mexico paintings, transposing them to a higher key of tonal intensity.

paintings, the reunion with a world of spiritual importance and significance energized him.

The mystical paintings effect a conjunction between his two most important periods: Maine and Berlin. Hartley had gone specifically to Mexico to get as close to the American Southwest as possible and still fulfill the requirements of the Guggenheim travel grant; it is no surprise that the landscape forms reproduce his New Mexico memory paintings. But now, in *Carnelian Country* and the others, they glow with the energy of his first Maine paintings. And the skies dance with the symbols he had first discovered and used in Paris and Berlin: triangles and constellations. As he wrote to Adelaide Kuntz: "I have a whole new program of sensations and experiences ahead of me as a result and am freed forever from aping nature as I have done for so long. For I have come to the point

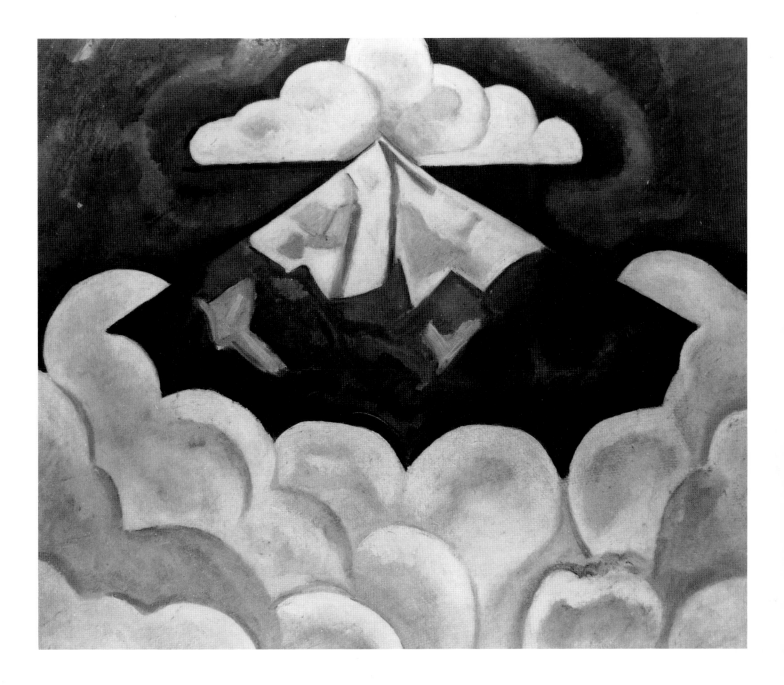

where it seems crass idiocy to keep on painting fruits and truck on a table. So this is what Mexico has done for me. . . . In other words I am really going to try to do now what I indicated in the 1913–15 period when I swung off into space and made pictures of just shapes and movements."

Hartley arranged the paintings he produced to form the panels of an "Arcane Library," emphasizing their thematic coherence. The decorations began with an animated version of one of the Amerika series, *Tollan, Aztec Legend*, in which a white bird with stars in its wings swoops down on the ruined pyramid. Then mountains make their appearance: first, *The Mountain of the North*, a vision of Atlantis by a medieval monk, and *Cascade of Devotion*, an image of an Aztec pyramid, suggesting the pre-Columbian vision of mountains. The centerpiece of the library was the tributes to the three mystics Hartley had redis-

Popocatépetl, One Morning, Mexico

1932. Oil on board, 23 x 28"
Courtesy Babcock Galleries, New York

One of a pair of views of Popocatépetl (existing in several versions), one "of the sublimest volcanoes the earth can boast of." Hartley, always thinking about mountains, equated the Aztec and Toltec pyramids with volcanoes.

Yliaster (Paracelsus)

1932. Oil on panel, 25¼ x 28½"
National Museum of American Art, Smithsonian
Institution, Washington, D.C. Museum purchase
made possible by the Smithsonian Collections
Acquisitions Program and by George Frederick
Watts and Mrs. James Lowndes

Yliaster is another name for Paracelsus, one of the mystics Hartley most admired, "meaning NOTHING, or the life-giving element in all things." The group of paintings it belongs to, all symbolic portraits of mystics, represent the soul's passage through the mundane world, from darkness to light.

Morgenrot

1932. Oil on canvas, 25 x 23″
Courtesy Babcock Galleries, New York

Morgenrot (Dawn) *honors Jakob Böhme, the German mystic Hartley had first discovered in Paris in 1912: "The hand of morning springs/from out the jubilant night," with a constellation of stars behind it.*

The Transference of Richard Rolle

1932. Oil on board, 28 x 26″
Private collection

In a poem on Rolle, a fourteenth-century English mystic and poet, Hartley exclaimed: "His home is in a morning cloud/and in his sackcloth-transported shroud,/he sings his molten migratory hymns."

covered for himself there: Paracelsus (Yliaster), Böhme, and Richard Rolle. At the very heart of the library were the two vertical works, *Morgenrot* and *The Transference of Richard Rolle*. The first vertical, a red hand with a constellation behind it, was a reference to the visions of Böhme, his favorite German mystic. In *The Transference of Richard Rolle*, an homage to the fourteenth-century English mystic and poet who came from the same district as Hartley's ancestors, Rolle's initials appear in pink clouds enclosed in a golden triangle, an image of triumph and transfiguration. Finally, in *Popocatépetl* (page 95), an idealized image of a Mexican volcano, "the morning cloud speaks with the great triangle"[2] of the mountain.

The other important work, completed almost a year after the event, was an elegy on Hart Crane's death. The work recorded the circumstances of the suicide: at about noon, or eight bells, with a ship foundering and a shark in the waters. Hartley revived the use of numbers and geometrical signs as well. The "8" on the red bell in the water recorded the time, with the men's eyes around it gazing at the newcomer to the depths of drowned men. On the sails, the "33" was Crane's age; while in a triangular cloud in the sky was another "8," a reminder of the number that Hartley associated with Freyburg (because of the eight-pointed German military star); in the water, under the shark, a "9," tripling the "3"s in the sails. The painting's symbolism was heavy-handed, but the work marked the first time Hartley had overtly connected an event in his life with his art since the *Portrait of a German Officer* (page 59) in 1915.

Ultimately, however, the life of the mind could only sustain Hartley so far, failing him as it always did; he craved distraction. He wrote to Adelaide Kuntz: "I have never felt so negated as to myself—or rather those diversions that run across a day and give it color and pulse—none of that here." In other words, he was missing his normal city life, which included friends and a little hanky-panky: "I am so bursting with need for some concrete touch of human."

Hartley had pinned his hopes on receiving a second year of the Guggenheim and had planned to spend it back in Germany, possibly in Hamburg. The grant failed to come through, much to his disappointment, but he stuck with his plans and left for Hamburg on April 20, 1933. What determined his final destination—the Bavarian Alps—was simple loneliness and sexual frustration. That spring in Mexico City he had seen a movie, *The Doomed Battalion*, four times. The star, Luis Trenker, was a perfect Aryan Alpinist, and Hartley sublimated his sexual attraction into something nobler, as always, by declaring Trenker "a man let into the secrets of the most profound nature there is, the mountain." His decision was made: "right then and there out of this film came my resolve to fly back to the nature that I know and stay there for the rest of my life, and the nature that I know is the NORTH." On that impulse he abandoned his mystical paintings and started on a whole new tack.

His last word on Mexico, as he sailed out of Vera Cruz, was directed at his destination: "The sense of one's own North leaps up now to cool the eyes and the senses—back to the Angles and the Aryans who have light in their faces, enough of the dark face and the dark concept . . . the North, Northward Now."

*Eight Bells Folly,
Memorial to Hart Crane*

1933. Oil on canvas, 30⅝ x 40⅜"
Frederick R. Weisman Art Museum,
University of Minnesota, Minneapolis.
Gift of Ione and Hudson Walker

Hartley's memorial to the poet Hart Crane "has a very mad look as I wish to have—there is a ship foundering—a sun, a moon, two triangular clouds—a bell with an '8' on it—symbolizing eight bells—or noon when he jumped off—and around the bell are a lot of men's eyes—that look up from below to see who the new lodger is to be."

Eight Bells Folly, Memorial to Hart Crane

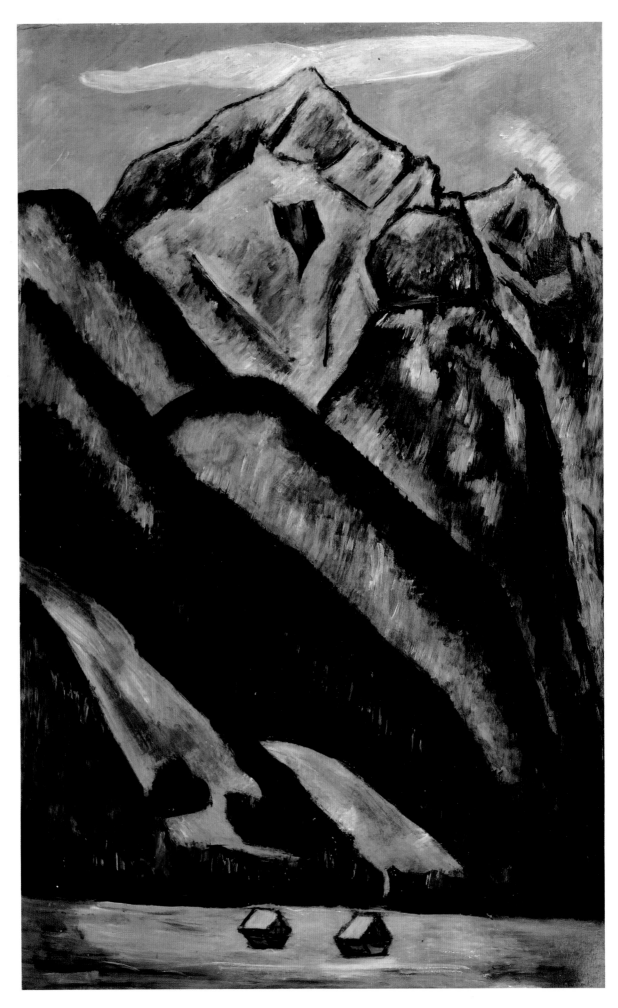

Garmisch-Partenkirchen (Alpspitz)

VIII. In Search of Site: Bavaria, Dogtown, Nova Scotia, 1933–37

DESPITE THE AESTHETIC SUCCESS of the Mexico paintings, Hartley knew his northward ways were set. The next few years were spent in a process of elimination, as he slowly resisted the inevitable conclusion that the end of his journey lay in Maine.

Behind his northward hankering, above all else lay his preference for northern men as well as northern culture. The attraction of Hamburg was, as he put it to one old flame, its "flares and shots."[1] He trawled enthusiastically through the bars and ogled the hordes of beautiful Hitler youth. After a year of the deprivations of Mexico, he stayed in Hamburg three months, and as he later told Rönnebeck, had "*certain joys* . . . when it comes to that angle of life no one understands it like the Germans and no one ever appeals to me as they did."

Hartley's romantic identification with Aryan youth presents a problem for a late twentieth-century audience. Even before the start of World War Two, Hartley's stay in Germany in 1933–34 was seen as pro-Hitler and anti-Semitic. Hartley's own feelings toward Jews were as complicated as his feelings toward Aryan Germany were strong. He always acknowledged his debt to Jews. In his autobiography written about this time he recalled: "It was Germans—German Jewish friends who offered me home—friendliness hospitality—bread—life—belief, and it was they who fed me out of their hearts—they who saw and believed in what they saw—they who have been doing it all my life—with one or two exceptions the only ones who have consistently believed and put their belief into operation." Hitler's policies disturbed him profoundly but he was not immune to anti-Semitism. As he wrote to his niece, he was happy to believe a friend who told him that when she had talked to Hitler about how wrong his policies were, Hitler had declared that he didn't hate Jews personally but felt that they were inappropriate for the future of Germany. Hartley attributed this problem to "the spirit of usury which is . . . their great defect." Hartley concluded his reflections to his niece with the comment: "[T]he youth will think of the jew as something to hate, and that is too bad." Hartley could accept the universal anti-Semitism but found it difficult to apply specifically: "There is a logic in this basically . . . if only it didn't produce such human tragedies. . . . Well, it is an awful issue, but for the rest I don't see but that it is just as rational and sensible to want to purify a race physically and mentally as not to do it . . . but the result is that all or most of the art has been paralyzed already." Nonetheless, even the arts were not entirely exempt from his anti-Semitism; later, back in the United States, Hartley was eager to call, for example, "the Peter Blumes and all that ilk

Garmisch-Partenkirchen (Alpspitz)

1933. Oil on board, 29½ x 18″
Bequest of Bertha Schaefer, Sheldon Memorial Gallery, University of Nebraska-Lincoln

Hartley saw his paintings of the Bavarian Alps as part of a program to paint mountains around the world. He hoped to capitalize on their German origin by selling them to Germans in America.

101

who are not at all Americans . . . peintres juif-Americains."[2] While his views were typical, they were not acceptable to everyone: he was hurt, for example, that the patron Ettie Stettheimer avoided him on his return for being pro-Hitler.

But such reflections were not on his mind at first. Hamburg was a place for pleasure, but not to paint. Viewing more Alpine films, especially a Franz Schmidt extravaganza set in the Bavarian Alps, "something came over me almost like faintness."[3] And so he went to seek his blonds in the Alps. Here, he thought, he would combine that sensation of mankind and mountain which Segantini had first evoked for him almost thirty years before, with real men and real Alps—even if he preferred the German side to the Swiss. The Alps too were the place where he had stayed with the spiritually inclined Franz Marc, and the memory of that visit reminded him that now, with the full mystical flood upon him again, he should head for the mountains, not the plains of Berlin.

Hartley first hunted for a place near where the Schmidt movies had been filmed, then settled for something cheaper, Garmisch-Partenkirchen, not too far from the Swiss border. But the familiar pattern of isolation led to a familiar result. Despite all his protestations to the contrary, the works reveal his lack of inspiration. The paintings are bold and strong, but heartless; and more to the point, the motifs of the "dark landscapes" return—the little houses huddled at the foot of forbidding mountains, now exaggerated in scale compared to the hills of Maine.

Hartley had hoped that his German paintings would find an audience with rich German-Americans (ironically, many of them Jews!) but his miscalculation was as bad as it had been in 1916.[4] Less than a year after leaving Mexico, he was back in the United States: with a worldwide depression in full swing, it was the only place he could reasonably hope for any money at all.

At first he thought the new Federal programs of support for artists would be the perfect thing. He lasted only a month before he quit. In 1936, he reluctantly went on the project rolls again, this time for more than three months. His only triumph was getting the WPA administrator, whom he darkly suspected of earning more than he did, to come to his studio to check him in and give him his money, rather than having Hartley waste his time going downtown to the office.

But Hartley was never cut out for communal projects or going along with the crowd. More serious was the need to find the right dealer, a problem he did not solve for many years. The sense of insecurity and competition acted like acid on his usual neutrality. He reserved his sharpest barb of all for Surrealism: the sneer that the paintings were "by women." While close to many women (especially Adelaide Kuntz and, earlier, Rönnebeck's fiancee, Alice Miriam) and supportive of several women artists, he never believed a woman artist could be as good as a man. His admiration for Georgia O'Keeffe's work was mixed with plenty of bile and envy at her success. His favorite term of disparagement was "feminine," masking, no doubt, fears that anyone would detect publicly his own lack of straight manhood. This had been true since the early 1920s when, writing to redeem the realm of the imagination in American culture, he had insisted on the masculinity of the painters Homer Martin, Ryder, and George Fuller.

In the midst of his troubles came another disaster: during the autumn of 1934 the storage bills on his paintings came due. He had assumed that Edith Halpert, the owner of the Downtown Gallery, which had represented him since 1932, had paid them as Stieglitz had done. Now two hundred fifty dollars had to be produced out of his own pocket. After anguished pleas for help, he managed to cover the costs, but only at the expense of consolidating four containers into one, and destroying a hundred paintings and drawings. Even though his best friend, the artist Carl Sprinchorn, saved him from destroying most of the paintings (and he admitted that much of what he destroyed "were too tentative, and most of them incomplete"), nonetheless, as he said to his niece, "with stilleto in hand I did quiet murder for four hard days." The blow was devastating, and Hartley deliberately heightened the melodrama by destroying the paintings on his fifty-eighth birthday.

Throughout this series of disasters Hartley continued to paint. A visit to Gloucester in 1934 produced more Dogtown paintings, which he worked on from memory for several years. These later images have a slightly finicky feeling to them, as the large boulders of the first group are replaced by decaying fences: the force of nature has been replaced by the failing hand of man. Then, after the debacle of the storage units, Hartley retreated to Bermuda and painted therapeutic, placid still lifes of flowers and colorful fish, choosing to produce decorative work which would sell (none did).

After Bermuda, he realized he could not go back to the same places to paint. Part of it was embarrassment—he could not face the artists he knew in Gloucester. But he also knew that he had little more to learn from familiar landscapes. Earlier he had toyed with the idea of going to China, to visit "the German boy that was with me in Berlin in the 1920–22 period."[5] He settled for a visit to Nova Scotia and the company of another companion from Berlin, the novelist Frank Davison. But when he got to the village of Lunenburg recommended by Davison, his friend was gone. With nothing else to do and finding Lunenburg unattractive, he decided to try a smaller village up the coast, Blue Rocks. Here he found the key to his final subjects, in the home of Francis and Martha Mason, in nearby Eastern Points.

Hartley was, in a sense, prepared for the Masons. He had grown up among French-Canadians in Lewiston. And as that other great Maine painter Winslow Homer had established in Hartley's youth, fishermen were the perfect model of a modern primitive hero. But Hartley's interest was, as always, personal rather than objective. Donny and Alty, the Masons' heroically built and exuberantly friendly, naïve sons, touched him: "I was swept away by the tidal forces of their humanism, and the two boys nearly devoured me with affectionate devotion."[6]

Hartley came back from Nova Scotia excited and, full of optimism, produced his brightest paintings in years, lush bouquets of fantastic flowers and opalescent radiant fish, such as *Flowers (Roses from Hispania)*. Another run-in with bronchitis and the WPA did not dampen his spirits and he even managed to get Stieglitz to take him on again and show the works at Stieglitz's new gallery, An American Place.

Flowers (Roses from Hispania)

Sea View, New England

1934. Oil on board, 12 x 16"
The Phillips Collection, Washington, D.C.

During 1934 Hartley returned to the very polished and commercial still lifes of the 1920s in an attempt to produce salable work. Here he combines the still life with his favorite window motif.

Flowers (Roses from Hispania)

1936. Oil on academy board, 23½ x 17¼"
Courtesy Berry-Hill Galleries, Inc., New York

This is one of six "Romantic Intervals for use as focus motives in a convalescent pavilion, chiefly neurotic." Others included "Roses" for a lonely child, for ladies, and for seagulls.

Fishnets and Lobster Traps

c. 1936. Pen and black ink with sepia
on paper, 9⅞ x 6⅞"
Bates College, Museum of Art, Olin Arts Center,
Lewiston, Maine. Marsden Hartley Memorial
Collection

These simple objects are emblems of the Mason family's trade. Hartley piles them up in recognizable space, but the impulse behind accumulating them is much the same as what motivated his German Officer paintings of 1915.

Rope and Wishbone

1936. Oil on board, 24 x 18"
Courtesy Vanderwoude Tananbaum Gallery,
New York

Hartley described these paintings as "portraits of . . . the objects at my feet everywhere which the tide washed up representing the visible life of places."

The flowers were well received but the Alpine pictures continued to be greeted with hostility. Hartley fumed: "I propose a 100% Yankee show next year to cram that idea down their throats till it chokes them even." But his main interest was getting back to Nova Scotia, back to the Masons, back to Alty, who lived "utterly for the consummate satisfaction of the flesh, the kind of flesh making no difference. . . . He will give as much love to a man as to a woman."[7] Another hyperbolic fantasy was in the making.

Hartley's paintings now took up the emblems of his new love. Concentrated on everyday things, they focused on them with the same intensity that Hartley had given to German uniforms. These buoys, nets, and fish were the signs and symbols of the life and work of a fisherman just as the abstractions of military officers had embodied the signs of that profession. The distance between the still lifes and the German Officer paintings was smaller than one might think—it was largely a matter of space and fragmentation. The impulse behind them was the same: the raising into significance of ordinary things through Hartley's passionate identification of these objects with the men. Both were "portraits," as he described them to Stieglitz; and in both, despite his protestations that he

IN SEARCH OF SITE

Rope and Wishbone

Northern Seascape, Off the Banks

Portrait of a Sea Dove

1935. Oil on composition board, 9¾ x 13¾"
The Art Institute of Chicago,
Alfred Stieglitz Collection, 1949

Hartley uses the dead sea dove as an emblem of almost Christian sacrifice: "Sea dove in a shroud/of sand . . . I closed my eyes on a kiss/of sun—/and this/I give to everyone."

wanted "no emotion of my own" in them, they were really portraits of the men behind them.[8]

But then, on Saturday night September 19, the boys were returning from a night out drinking, a storm blew up, and they drowned with their cousin Allan. "I haven't felt anything like it since the death of Karl von F. who as you well know became an image in my spiritual experience," he wrote to Rönnebeck. The pain was the bitterest. Foolish hopes for a different life had been dashed utterly: "The biggest one wanted to build a little shack with me and live in it with me—as he was 'off' women he said because the one girl he thought he wanted jilted him."

The family asked Hartley to stay until December, which he painfully did. With *Northern Seascape, Off the Banks,* he began a series of elegies, in which he painted the sea directly for the first time since his youth, conflating the works of Ryder and Homer: Ryder's dreamlike clouds and Homer's threshing rocks. And then he beat a retreat back to New York, promising to return but never having the courage.

That April he was to have his last show with Stieglitz, for which he wrote an essay, "On the Subject of Nativeness—A Tribute to Maine." Ironically, none of the works in the exhibition depicted Maine or was painted there, but Hartley, after this second great loss of hope and love, had already spiritually returned to his roots. He praised the "directness and trust" in northern faces and character, their simplicity and silence. He explained that "to the Maine-'iac' New England is never anything but Maine," and then praised the state's artistic accomplishments in poetry, music, and painting, with Ryder leading the list. "Nativeness is built of such primitive things, and whatever is one's nativeness, one holds and never loses no matter how far afield the traveling may be." So Hartley defended his past, and promised, at last: "I wish to declare myself the painter from Maine."

Northern Seascape, Off the Banks

1936–37. Oil on cardboard, 18³⁄₁₆ x 24"
Milwaukee Art Museum Collection,
Bequest of Max E. Friedmann

Hartley's first painting after the death of Donny and Alty Mason, this elegy pits the two boats representing the boys against a threatening sky and savage rock-toothed shore.

Crow with Ribbons

IX. Maine-"iac," 1937–43

DESPITE THE DECISION TO RETURN TO MAINE, leaving New York was not easy. The last exhibition with Stieglitz was a failure—nothing sold—and in desperation Hartley wrote begging letters wherever he could, acknowledging that Stieglitz's reputation for exclusivity and aloofness might have hurt his own reputation. He found a sympathetic but neophyte dealer in Hudson Walker, an adequate solution for a time. Then the Whitney Museum came through with the purchase of a Dogtown painting. With that eight-hundred-dollar sale in his pocket and his dealer settled, Hartley went back to Maine at last. He arrived in Georgetown, a small town not far from Boothbay Harbor and Portland in the south of the state, in June 1937.

Two questions faced Hartley on his return: where to live and what to paint? The first was not answered for several years. Georgetown was only a summer retreat and Hartley tried Portland, Maine's biggest city, for his first winter. The next summer he ventured to Vinalhaven, an isolated island off the coast (chosen because it reminded him of Nova Scotia); and then retreated to Boston for the winter, having had a little much of Maine. In 1939, after spending nearly four months in New York, he tried out Portland, West Brooksville, and Bangor. Not until the next summer did he settle on the isolated fishing village, Corea— another version of Eastern Points—as his summer home, "so like the one I lived in up in Nova Scotia—the mind wept if the eyes couldn't."[1] There he found another family, Forest and Katie Young, and stayed with them until the winter and loneliness drove him to the city, either Bangor or New York. Even then he kept hoping for warmer or more cosmopolitan climes, angling for teaching jobs in the Southwest or considering painting trips to the Smokies or Seattle. Partly in response to the ambivalent public reception of his paintings, he also took up writing with a vengeance, planning several books of essays on a wide variety of topics, a book on the circus, poetry, and his autobiography. Only the poetry was published, although he made several attempts to have his other work accepted.

Hartley's art did not display the same indecision or lack of focus. He ranged across as many subjects as he did places to live but touched on all of them with a commanding authority, from *Sea Window, Tinker Mackerel* to *Crow with Ribbons*. Upon arriving in Georgetown in the summer of 1936, he self-consciously returned to such favorite motifs from his youth as waterfalls, in *Smelt Brook Falls* attempting to recover himself as "the painter from Maine."

The next year he finally began to work out the aftermath of the deaths of Donny and Alty Mason for himself. These paintings marked a radical change in subject: for the first time, Hartley began to paint the human figure seriously.

Crow with Ribbons

1941. Oil on masonite, 28 x 22"
Hirshhorn Museum and Sculpture Garden,
Smithsonian Institution, Washington, D.C.
Gift of the Joseph H. Hirshhorn Foundation, 1966

Hartley was delighted when people compared his paintings of dead birds to Ryder's famous painting of a dead songbird, now in The Phillips Collection. The crow, however, began to smell before Hartley could finish painting it, so it was completed from memory.

Sea Window, Tinker Mackerel

1942. Oil on masonite, 40 x 30"
Smith College Museum of Art,
Northampton, Massachusetts.
Purchased, Sarah J. Mather Fund, 1947

In his last years, Hartley returned on occasion to still-life motifs he had used for years, including his "sea windows," first painted in Bermuda in 1917.

Smelt Brook Falls

1937. Oil on board, 28 x 22"
The Saint Louis Art Museum,
Museum Purchase: Eliza McMillan Fund

Hartley's paintings of waterfalls in 1937 are a conscious return to one of his first Maine subjects exhibited in 1910.

The first set of paintings inspired by the Masons, completed in November 1938, consisted of a portrait of Donny and his father at work in the sleet over their nets; an image of gulls attending dead fish on the beach (its objectivity strained by a mystical central eye in the forehead of the central bird and the title, *Give Us This Day*); and a portrait of Albert Pinkham Ryder. These three paintings announced the major concerns of his exploration of figure painting: memory, spirituality (both Christian and mystical), and the male figure.

He extended this first group into portraits of the Mason family, given French-Canadian names of Hartley's invention (to mask their identity and preserve the family's anonymity as he had promised): *Fishermen's Last Supper*; *Cleophas, Master of the "Gilda Gray"*; *Adelard the Drowned, Master of the "Phantom"*

Smelt Brook Falls

(pages 115–17); *Marie Sainte Esprit* (not illustrated), and *The Lost Felice* (page 118). As Hartley told Sprinchorn: "I want to get back to real series again and do my own sort of a mural, purely for myself. I get sick of doing small things for exhibition purposes, entertaining the public and getting little or nothing out of it for myself." He intended this group for the walls of a fishermen's memorial chapel.

The spirit behind these paintings was both Christian and pagan. Francis Mason's intense Catholic piety had impressed Hartley with its sincerity, and the family's stoic, calm response to the tragedy moved him deeply. Christian faith still sustained these simple people. Hartley now began to integrate into his art (if not his life) more overtly Christian subjects. But the romance with the Masons as a family also sprang from his need to return to the native and primitive, to flee as far as possible the insincerities and inauthenticities of modern life, the same emotion which motivated so many artists at the turn of the century from Gauguin in Tahiti to Homer in Maine. Hartley called these portraits "archaic." He claimed that Coptic textiles, which he was now beginning to collect, influenced him, as well as ancient Fayum portraits and the early Renaissance masters. At the same time their archaism was inherent in their subjects. As he claimed in "On the Subject of Nativeness—A Tribute to Maine": "That hardiness of gaze and frank earnestness of approach which is typical of all northerners . . . is sometimes as refreshing to the eye as cool spring water is to

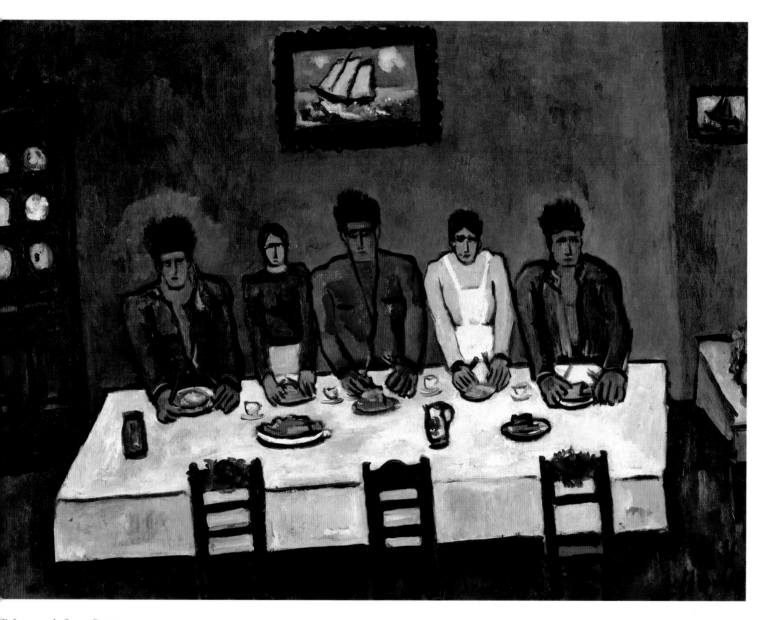

Fishermen's Last Supper

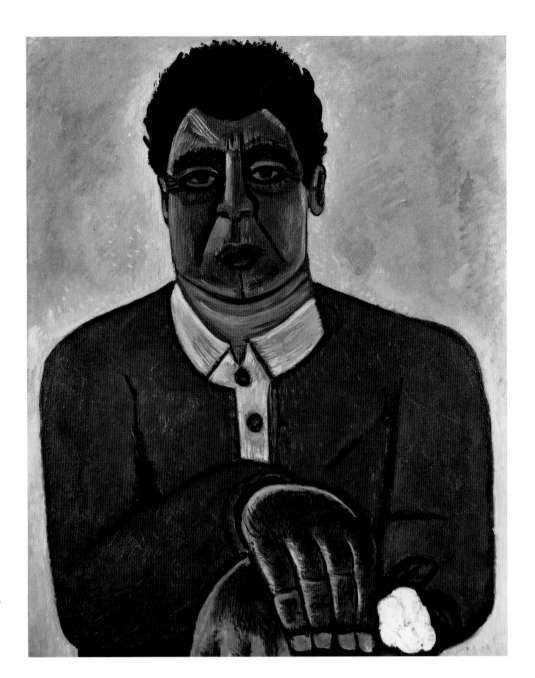

the throat. . . . If you are seen, you are seen 'through,' there is no mystery you can offer." For once and at last, Hartley had been "seen" entirely clearly; for once he had not hidden behind glances, signs, and symbols. The Masons in their simplicity had seen him straight. The directness of the portraits reflect their gaze. And now he could paint without indirection the subject he had always hidden from: human beings, men.

Of course, for an artist as tried and sophisticated as Hartley, the decision to do figure painting was not without its calculation. Figure painting still claimed critics and audiences more strongly than other genres. Walt Kuhn was at the height of his critical success as a painter of clowns and vaudeville figures—emblems of modern alienation and American hardiness—and to a very great degree the flatness and frontality of Hartley's figures were modeled on Kuhn's

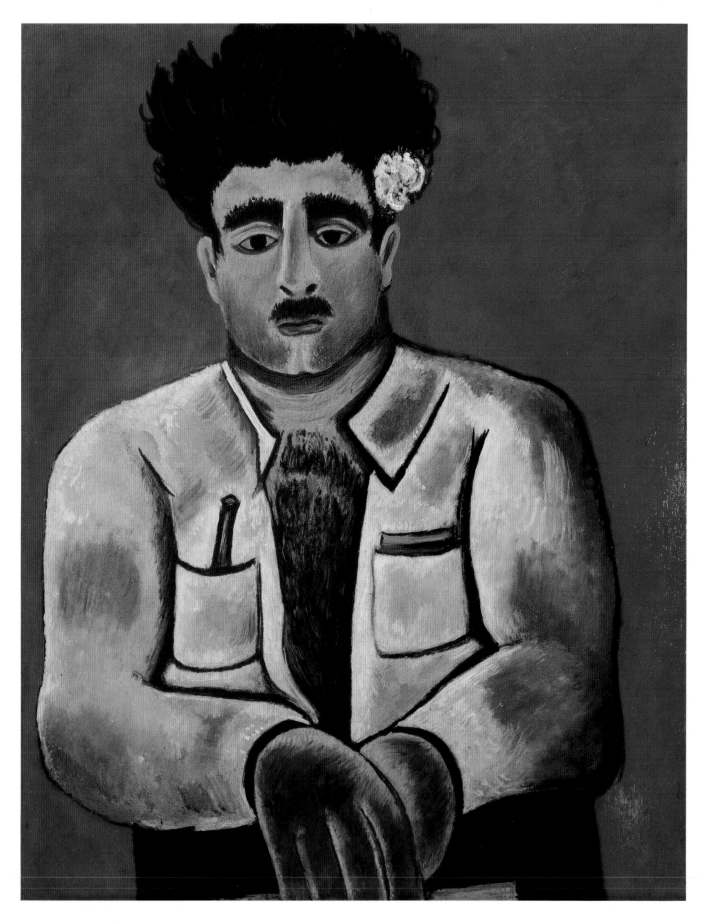

Adelard the Drowned, Master of the "Phantom"

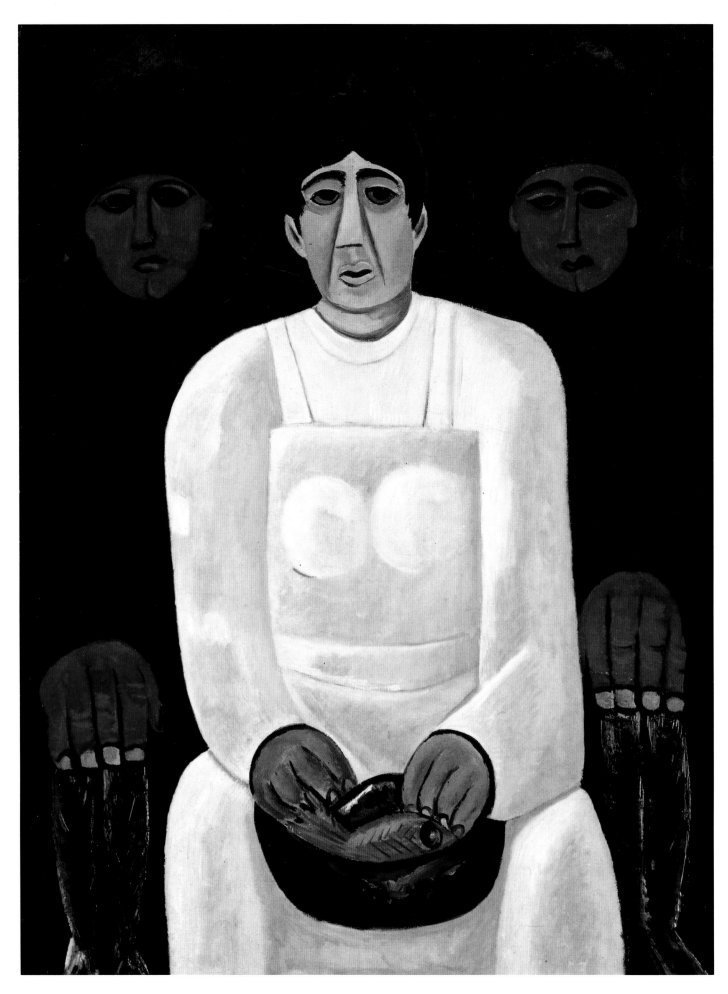

The Lost Felice

(although Hartley generally reserved an interest in vaudeville and circuses for his writing). Hartley was also aware of Georges Rouault's work, "one of the grandest names of all in the modern art world" in Hartley's opinion.[2] But whatever the sources and market positioning that lay behind these paintings, their strength and sincerity proved self-evident: Hartley's first venture into figure painting was a critical success.

Hartley's landscape paintings during these years must be understood as an extension of his images of men—or vice versa. As he said in his tribute to Maine, the natives of northern places, "hard boned sturdy beings . . . have the direct simplicity of these unique and original places." People and place shared the same character. Although comparing the stony land with the people in his writing, in his paintings he focused first on water, as if to acknowledge the forces of time and chaos which wear down both men and mountains. After years of denial, Hartley faced his age and a lifetime of disappointment in his art; the temporal face of nature began to appear, its power to change as opposed to its power to confront.

It didn't hurt that he now lived by the ocean. He could never forget that it was an inimical place, capable of great beauty but guilty three times over of taking men Hartley had loved. In his paintings, the land stands against the force of the ocean obdurately. At first it would seem as though the ocean wins: Hartley is more interested in the power of the water, the strength of the waves whether whipped up by a storm or just running high, as in *The Spent Wave, Indian Point, Georgetown, Maine*. But as he worked on the subject, his emphasis changed. In his last great painting of the ocean, *Evening Storm, Schoodic Maine* (1942), the resistance of the land seems matched to the force of the ocean, and within the mountainous wave unfolds a flower-like form of water vapor. Commemorating the boys' death in one of many poems, Hartley described the "stiff tone of death/in every wave." But then he asked the question: "What more can wave have/save perhaps a little love/or the look of something/only flowers leave/when they pass,/precise curve,/soft breath."

However, the centerpiece of this return to Maine and its landscape was not Hartley's experiences at its liminal edge, facing the endless Atlantic; rather, it was a trip to the heart of the state, both literally and mythologically, to Mount Katahdin. From his return to America in 1930, he had wanted to visit the mountain,[3] sacred both to Native Americans and to Thoreau, who had stood on its slopes and exclaimed: "I stand in awe of my body, this matter to which I am bound has become so strange to me. I fear not spirits, ghosts, of which I am one,—*that* my body might,—but I fear bodies, I tremble to meet them. What is this Titan that has possession of me? Talk of mysteries!—Think of our life in nature,—daily to be shown matter, to come in contact with it,—rocks, trees, wind on our cheeks! the solid earth! the *actual* world! the *common sense! Contact! Contact! Who* are we? *where* are we?" Hartley had known these very words, these same fears, and these questions all his life.

In October 1939 he finally arranged to go. It was late in the season, and the trip was physically arduous, culminating in a trek over a bad road for four miles

The Lost Felice

1939. Oil on canvas, 40 x 30"
Los Angeles County Museum of Art, Mr. and Mrs. William Preston Harrison Collection

Hartley intended these "archaic portraits" to be "For a Seamen's Bethel in the Far North." "Marguerite Felice" is Alice Mason, flanked by her dead brothers.

The Spent Wave, Indian Point, Georgetown, Maine

1937–38. Oil on panel, 22½ x 28½"
Columbus Museum of Art, Ohio. Museum
Purchase: Howald Fund II, 1981

Hartley's paintings of the Maine coast in 1937 were his first since his student days. They represent both a way to make a new start in Maine, and an effort to build on the sensations explored in Northern Seascape, Off the Banks *(page 108).*

Evening Storm, Schoodic, Maine

1942. Oil on composition board, 30 x 40"
The Museum of Modern Art, New York. Acquired
through the Lillie P. Bliss Bequest

Hartley visited Schoodic when he was driven there in November 1941 by the Youngs' daughter. He loved the "stormy seas and big crashing waves" he saw, and did at least three versions.

to reach Cobbs Camp, where he stayed for eight days. He was guided in and out by a game warden, Caleb Scribner, who seemed to Hartley to be the embodiment of the landscape: "he that had Ktaadn [*sic*] in his flesh and bone,/and the look of windbeaten eyries in his eyes." Here again, it was the identification of the man with the mountain that energized the experience.

Hartley began to work up his sketches as soon as he returned to Bangor, and over the next three years produced two sets of large paintings, each set containing six paintings, as well as a number of smaller studies. The paintings represented a suite of seasons and moods which pass across the face of the indomitable mountain. Hartley, in effect, returned to his first subject, with some significant differences. This was now not one of the mountains he had grown up with but a special one, a spiritual center. Instead of pressing close on him, in a swirling storm of pigment and color, the effects were remote and grand. Hartley's first paintings of mountains had been romantically incandescent; these have the serenity and the strength of old age. His answer to Thoreau's fears and questions was: I have lived, I have survived, I have returned home alive, that will be sufficient.

As always an element of expedience enforced by years of penury entered into the scheme of the paintings. Hartley wanted to get back to Katahdin to get other views. He wrote to Hudson Walker that he wished "to paint one view from Baxter Park and one from Toque [Togue] Pond—both official Appalachian [Trail] views and must do them with more realism if possible as those people look for the branches in the hills, etc." Fortunately, he never returned to

Evening Storm, Schoodic, Maine

Mount Katahdin, Autumn No. 2

1939–40. Oil on canvas, 30 x 40¼"
The Metropolitan Museum of Art, New York.
Edith and Milton Lowenthal Collection, Bequest
of Edith Abrahamson Lowenthal, 1991

*Mount Katahdin had been a famous site
for artists a century before Hartley final-
ly got there in October 1939, after years
of wanting to. He visited it only once but
painted it several times.*

Mount Katahdin

1941. Oil on fiberboard, 22 x 28"
Hirshhorn Museum and Sculpture Garden,
Smithsonian Institution, Washington, D.C.
Gift of the Joseph H. Hirshhorn Foundation, 1966

*Hartley returned to Mount Katahdin in
his paintings yearly, imagining it in different
lights and seasons.*

Mount Katahdin, Maine

1942. Oil on hardboard, 30 x 40⅛"
Gift of Mrs. Mellon Byers. © 1992
National Gallery of Art, Washington, D.C.

*The suite of large views of Mount Katahdin
which Hartley created over the years
make a group of paintings similar to the
first ten Maine mountains he exhibited
with Stieglitz in 1909, a transcendentally
intense scrutiny of a single, magical
site.*

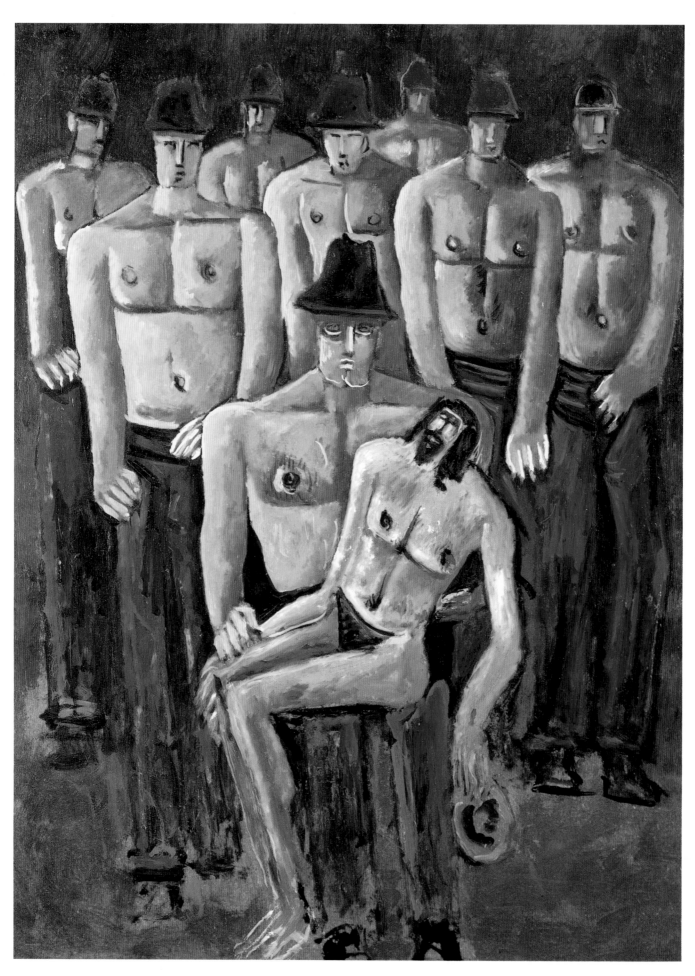

Christ Held by Half-Naked Men

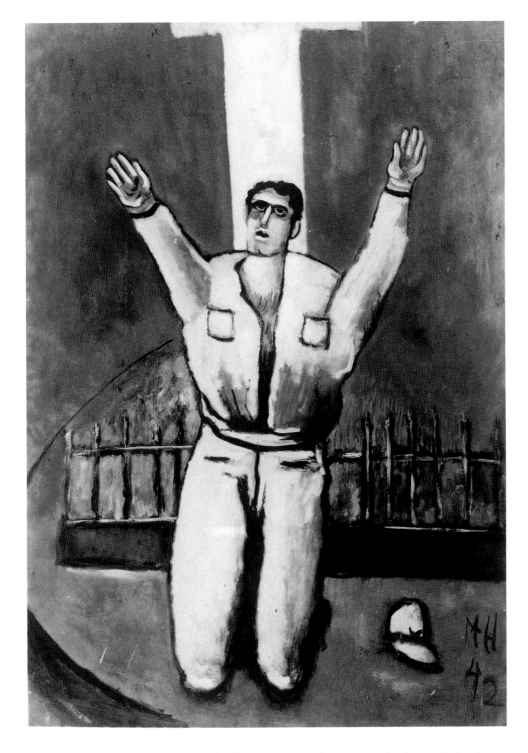

Katahdin and his paintings gain from the way the mountain burned singly on
his inward eye, unclouded by other memories.

The Mount Katahdin series brought to an end a subject which had obsessed
Hartley from his first days; the "archaic portraits" announced a rich new vein.
Moreover, the loss of the Masons was amplified by events in Europe. Although
he could no longer "speak the word German with grace," as he said to his pub-
lisher, Leon Tebbetts, the onset of war must have seemed a horrifying reenact-
ment of his first great tragedy, unfolding with the same inevitability and
remorselessness. The paintings of the Masons were elegies for them and to the

destruction of Hartley's idealized family. Another suite of works, including *Christ Held by Half-Naked Men* (page 124), was explicitly religious and dealt with larger issues of sacrifice. Just as Hartley had said of Freyburg that his death was the greatest sacrifice and tragedy of the war, so did the Masons' deaths resonate now in his mind with the sacrifice of Christ and war in Europe. He connected all three in a poem entitled "What Is Sacrament": "The sea is wild and black and black . . . sabers clash; bombs go spitting out/their well-timed murder . . . Nothing of itself is sure,/even the unborn wondering, what/is sacrament."

The straightforwardness of his figure paintings forced him to bring together his separate selves explicitly for the first time, but not without a certain reluctance. He showed Marianne Moore his poems about Freyburg and then regretted it, "as the poems were all about a transparent case of platonism."[4] As he wrote to his composer friend Roy Newman: "I destroyed the first half of the volume of poems I let you read—chiefly because I didn't want that aspect of human experience to be part of the personal record—and I have left the dual aspect behind me anyhow."[5] He would claim at the end of his life, as he always did: "I have no interest in the subject matter of a picture, not the slightest."[6]

But his "dual aspect" emerged forcefully in a series of paintings in which his sexual fantasies began to step forward into clear light. The sailors, athletes, loggers, swimmers, and beautiful men who had populated his letters now appeared in his paintings. *Canuck Yankee Lumberjack* (page 129), for example, makes an overt reference to Cézanne's painting of a male bather, but whereas Cézanne's figure is hardly physical, Hartley's is a man, with big muscles, hair, and his penis outlined in his tight trunks. Hartley made scores of drawings of men on the beach, luxuriating in their variety of poses and bodies, making do by looking at what he couldn't touch. Which is not to say he wasn't active in places where he would not disturb his home community. When Robert McAlmon wrote to Hartley that William Carlos Williams was boasting how well-hung his newborn grandson was, Hartley replied: "I too was born that way, and still have plenty to carry, but did I get fun out of the arrangement, and well, I am still doing it and no diminution of the foolish idea."

The war situation made the sexuality of the figures all the more poignant. His visits to New York were a paradise of "navies in white duck, and the thighs and arses something to tell mother about—simply wonderful." He clipped photographs from the newspapers of soldiers and even based paintings on them, making one last attempt to record these beauties before the war destroyed them, remembering perhaps his inability to do so before the last war. All these studies, whether elegiac, religious, or erotic, served as paeans to the young men who would soon disappear forever.

In the last three years of his life, he finally began to make enough money to relax from the financial terrors of the previous decade. He toyed with the idea of buying land and building a small house near the Youngs in Corea. He began to accumulate *objets d'art* as he had not in nearly twenty years, particularly a group of Coptic textiles and other minor Egyptian fragments. Most important, after Hudson Walker decided to close his gallery, Hartley was taken on by the

Madawaska-Acadian Light-Heavy

1940. Oil on hardboard, 40 x 30"
The Regis Collection, Minneapolis

One of several paintings ideally intended for gymnasiums, Hartley wrote to his Canadian friend Frank Davison of this model whom he discovered in the YMCA: "My model last year at the art school in Bangor and who posed for me privately God what a magnificent corps—is a Madawasca boy of Acadian descent . . . a prizefighter . . . and is such a sweet lad—22."

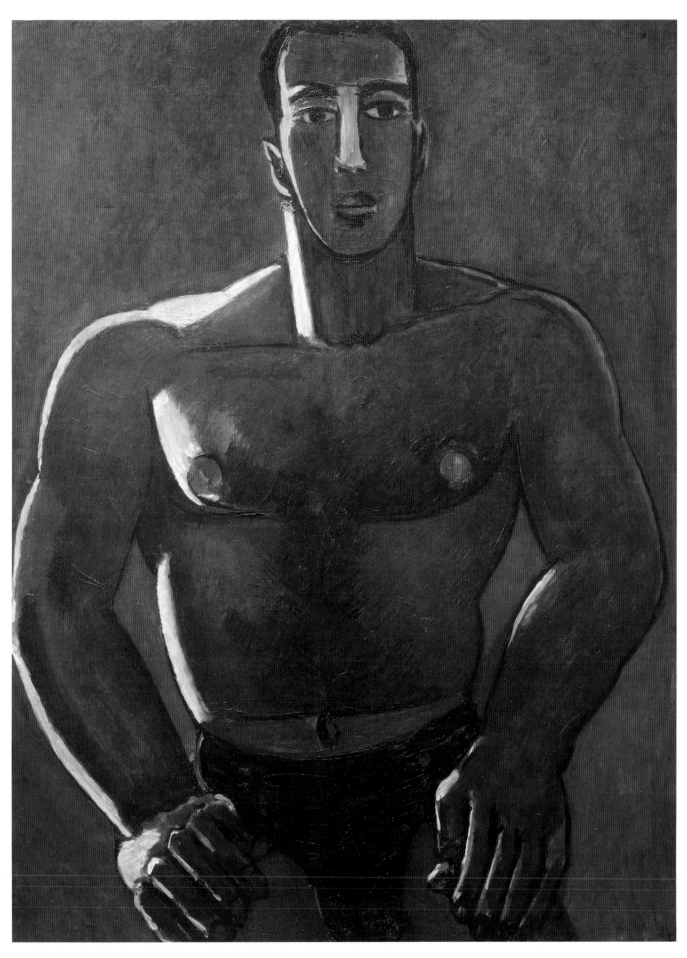

Madawaska-Acadian Light-Heavy

dealer Paul Rosenberg, who had showed only Picasso, Matisse, and other European masters: Hartley was his first American. Hartley was immensely proud of the honor, as well as the fact that his work was now entering museums at a fast pace.

But just as his worth was finally being recognized, the deprivation of so many years began to catch up with him. His health—high blood pressure being only one problem—began to fail. Adelaide Kuntz remembered vividly the last time she saw him in New York, when he took her and her son out for dinner on the roof of his hotel. After they were seated, he said: "'Now they can see that I am not just that weird lonely man they have thought, but that I have family too— May I call you that?' It was infinitely touching to me, especially as I sensed his pride in being able at last, after all the years of fear of spending, to entertain his friends with some lavishness. I shall always remember him like that, with

Canuck Yankee Lumberjack at Old Orchard Beach, Maine

his extraordinary gaze steadfast under the glow of the late sun in his face."

A little over a month later, he was dead, alone in a small hospital in Ellsworth, Maine, six hours after desperately begging the Youngs to let him stay in his own room, to let no one touch him but them: "Just let me stay in my little room. I love it there, it is home. I promise not to be any trouble and all my things are in that little home."[7] He had written to his niece a few years before that he should be cremated and that his epitaph should read: "Here lived one who did the best he could with what there was and all in all liked the struggle."

Hartley's insistent claim that art should not be divided from life—a point of view mandated by Robert Henri at the turn of the century and rarely contradicted since in American art—always ran up against the brick wall of his gay closet. His fear that his painting might not be taken as "masculine," his unpleasant disparagement of the work of others as "feminine," arose in part from a fear of discovery. But at the same time Hartley's concern with gendered painting was not limited to him. His words—"I want the whole body, the whole flesh, in painting. Renoir said that he painted with all of his manhood, and is it not evident"—are echoed later in Harold Rosenberg's statement that instead of making images, the "action painter" of the generation following Hartley went to his easel "with material in his hand to do something to that other piece of material in front of him." This urge to defend painting's manhood was, in part, an overreaction on the part of artists whose "manhood" was not conventional or unambiguous. There is a long line of them in American painting—from Winslow Homer to Hartley to Jackson Pollock and beyond. As Kenneth Silver has recently said: "Artistic authenticity is the concomitant of identifiably masculine behavior . . . sissies don't make real art."[8] Gay or straight, authenticity derived from masculine experience has been one of the master narratives of American culture. It is Hartley's triumph that he changed or subverted this narrative so often. Hartley's greatest paintings arise in the moment when the pressure to hide his sexuality breaks down under the tragedy of his experience.

Young Seadog with Friend Billy

1942. Oil on masonite, 40 x 30"
The Regis Collection, Minneapolis

"My beautiful blue and black plaid cap on—some burning spots of blue for eyes—Billy the Bantam on my shoulder which is a daily trick and a lobster hanging down from left hand or left knee— all very typical and I have every reason to believe will be a likeness, that is for me."—Letter to Carl Sprinchorn, 1942

Young Seadog with Friend Billy

Notes

I cite here only those facts and quotations which might be difficult to locate easily in both published and unpublished materials. Where the correspondent or source has been mentioned in the text, I have generally not cited the document unless the location is obscure. The correspondents and documents mentioned in the text may be located in the Selected Bibliography.

Introduction

1. Letter to Gertrude Tiemen, February 8, 1938, Elizabeth McCausland Papers, Archives of American Art (hereafter cited as AAA), (roll D268, frame 761).
2. Postcard to Mabel Dodge Luhan, June 22, 1914, Yale Collection of American Literature, Beinecke Rare Book and Manuscript Library, Yale University (hereafter cited as Yale).
3. "Testament Finals," unpublished poem, Yale (roll 1371, frame 4040 AAA).
4. Letter from Chenoweth Hall to Elizabeth McCausland, April 20, 1961, McCausland Papers, AAA (roll D271, frame 662).
5. Letter from Robert McAlmon to McCausland, December 18, 1951, McCausland Papers, AAA (roll D269, frame 801).
6. "Art—and the Personal Life," repr. in Marsden Hartley, *On Art*, ed. Gail Scott (New York: Horizon Press, 1982), p. 71.

Chapter I. Becoming an Artist and a Man

1. Marsden Hartley, *Adventures in the Arts: Informal Chapters on Painters, Vaudeville and Poets* (New York: Boni & Liveright, 1921), p. 6.
2. Hartley Collection, Olin Arts Center, Bates College, Lewiston, Maine.
3. Letter to Alfred Stieglitz, February 8, 1917, Yale.
4. Letter to Nina Waldeck, January 14, 1942, Yale.
5. See Philip Isaacson, "One Man's Treasure," *Bates: The Alumni Magazine*, 82d ser., no. 3 (May 1984), [Bates College], pp. 3–7.
6. Walt Whitman, "Among the Multitudes" and "Spontaneous Me," quoted in Townsend Ludington, *Marsden Hartley: The Biography of an American Artist* (Boston: Little, Brown, 1992), p. 31.

Chapter II. Maine and New York, 1906–11

1. Letter to Horace Traubel, December 6, 1906. This, and all other correspondence with the Traubels, is published in *Heart's Gate: Letters Between Marsden Hartley and Horace Traubel, 1906–1915*, ed. William Innes Homer (Highlands, N.C.: The Jargon Society, 1982).
2. "On the Subject of the Mountain: A Letter to Messieurs Segantini and Hodler," in Jeanne Hokin, *Pinnacles and Pyramids: The Art of Marsden Hartley* (Albuquerque: University of New Mexico Press, 1993), p. 136.
3. Letter to Peggy Frank, March 1941, McCausland Papers, AAA (roll D268, frame 987).

Chapter III. Paris, 1912–13

1. "Pre-War Tale—Paris 1913" (also titled "Pleasure"), unpublished story in "Twenty-five Essays (European Topics)," Hartley Papers, Yale (roll 1369, frames 2024–27, AAA); another version appears in "Small Episodes," in "Twenty Essays" (roll 1369, frames 1641–43, AAA).
2. Letter to Stieglitz, September 1, 1912, Yale.
3. Letter to Stieglitz, July 30, 1912, Yale.

Chapter IV. Berlin, 1913–15

1. "Forward," in "Somehow a Past," ms. version, Yale (roll 1371, frame 3243, AAA).
2. "Window Shopping at Night," in "Twenty-five Essays," Yale (roll 1369, frames 1903–7, AAA).
3. "Leather," filed with "Somehow a Past," ms. version, Yale (roll 1371, frame 3374, AAA).

Chapter V. Home Again, 1916–21

1. Letter to Carl Sprinchorn, 1917, McCausland Papers, AAA (roll D267, frame 1260). For a few years Hartley's letters are full of revulsion against everything which had excited him before: militarism, soul, mysticism, abstraction. See his letters to Stieglitz and those quoted in Ludington, *Hartley*, pp. 134, 135.
2. Letter to Sprinchorn, April 1, 1932, Yale.
3. Paul Rosenfeld, *The Port of New York* (New York: Harcourt, Brace, 1924), p. 95.
4. Recollections of Mrs. Dvorak (Alice Miriam's sister), McCausland Papers, AAA (roll D271, frame 263).
5. Hartley, *Adventures in the Arts*, p. 172.
6. Letter to McAlmon, December 18, 1940, Yale.

Chapter VI. Wanderjahre, *1921–31*

1. Letter to Stieglitz, November 30, 1921, Yale.
2. Letter to Stieglitz, December 18, 1924, Yale.
3. Letter to Donald Greason, April 15, 1933, McCausland Papers, AAA (roll X3, no frame numbers).

Chapter VII. Mexican Interlude, 1932

1. Letter to Norma Berger, July 2, 1932, Yale.
2. "Miscellaneous Notes," Yale (roll 1371, frames 4073, 4074, AAA). This draft of the essay for the Mexican exhibition catalogue contains descriptions of several works.

Chapter VIII. In Search of Site: Bavaria, Dogtown, Nova Scotia, 1933–37

1. Letter to Greason, March 21, 1933, McCausland Papers, AAA (roll X3, frame 3).
2. Letter to Adelaide Kuntz, December 12, 1933, McCausland Papers, AAA (roll X4, no frame number).
3. Letter to Kuntz, July 22, 1933, McCausland Papers, AAA (roll X4, no frame numbers).
4. Letter to Berger, December 1933, Yale.
5. Letter to Arnold Rönnebeck, March 26, 1935, McCausland Papers, AAA (roll X3, no frame numbers).
6. Letter to Kuntz, November 4, 1935, quoted in Gerald Ferguson, *Marsden Hartley and Nova Scotia* (Halifax, Nova Scotia: Mount Saint Vincent University Art Gallery, in association with The Press of the Nova Scotia College of Art and Design and the Art Gallery of Ontario, 1987), p. 39.
7. From "Cleophas and His Own," in Ferguson, *Marsden Hartley and Nova Scotia*, p. 98.
8. See Ludington, *Hartley*, pp. 252, 255.

Chapter IX. Maine-"iac," 1937–43

1. Letter to Helen Stein, September 10, 1939, Stein Papers, AAA (roll 4130, frame 426).
2. Marsden Hartley, "Pictures," in *Marsden Hartley/Stuart Davis*, exh. cat. (Cincinnati, Ohio: Cincinnati Modern Art Society, 1941), p. 5.
3. Letter to Berger, September 20, 1933, Yale.
4. Letter to McAlmon, December 18, 1940, Yale.
5. Letter to Roy Newman, July 21, 1938, Marsden Hartley Letters, AAA (roll D10, frame 1260).
6. "Pictures" (Cincinnati), p. 4.
7. Katie Young to Hudson Walker, Autumn(?) 1943, McCausland Papers, AAA (roll D267, frame 66).
8. Kenneth E. Silver, "Modes of Disclosure: The Construction of Gay Identity and the Rise of Pop Art," in Donna De Salvo and Paul Schimmel, eds., *Hand-Painted Pop: American Art in Transition 1955–1962* (Los Angeles and New York: Museum of Contemporary Art and Rizzoli, 1992), p. 181.

Chronology

1877 January 4: Edmund Hartley is born in Lewiston, Maine.

1885 March 4: Eliza Jane Hartley, his mother, dies.

1889 August 20: Thomas Hartley, his father, marries Martha Marsden and soon moves to Cleveland, leaving Hartley behind.

1893 Moves to Cleveland to rejoin family.

1896 Takes first art lessons with a local landscape painter, John Semon.

1898 Wins a scholarship to the Cleveland School of Art, followed next spring by a five-year fellowship. Studies with Cullen Yates and Nina Waldeck.

1899 Fall: Moves to New York to study art at the New York School of Art (the Chase school). For the next seven years, spends summers in Maine, often in North Lovell.

1900 Fall: Transfers to the National Academy of Design. Studies with Francis C. Jones and others.

1904 November: Fellowship ends; works and tours with Proctor's Theater Company.

1906 Fall: Returns home to Lewiston; adds his stepmother's name, and then drops his first name. Offers art lessons.

1907 Summer: Works at Green Acre, a utopian community in Eliot, Maine. First exhibition, at the home of Mrs. Ole Bull at Green Acre.

1908 Spring: Exhibits paintings at Rowlands Gallery, Boston; Desmond Fitzgerald, a prominent collector, buys *Maine Blizzard*.

 Fall: Returns to North Lovell, paints his first major works.

1909 April: Meets Stieglitz in New York; first one-man show at 291 in May; has eight more solo shows with Stieglitz, the last in 1937. The dealer N. E. Montross shows him work by Albert Pinkham Ryder.

1911 March: Exhibits 15 works in the Independents Exhibition. Sees Picasso's work and produces first abstraction.

1912 April 11: Arrives in Paris.

 Summer: Meets Arnold Rönnebeck and Karl von Freyburg. Meets Gertrude Stein and sees her collection. Reads *Der Blaue Reiter* and Kandinsky's *On the Spiritual in Art*.

 November: Begins "intuitive abstractions."

1913 January 3: Leaves for a visit with Rönnebeck in Berlin.

 January 24: Meets Kandinsky and Marc in Munich.

 February: Included in the Armory Show in New York.

 April: Leaves Paris for Berlin; stays with Franz Marc in Sindelsdorf for four days; arrives in Berlin in May.

 September: Five "intuitive abstractions" exhibited in Erster deutscher Herbstsalon, Berlin.

 November 15: Leaves for New York.

1914 April 30: Arrives back in Berlin.

 August: Germany declares war on the Allies. Learns later that his father died August 4.

 October 7: Karl von Freyburg killed in battle.

1915 May: Martha Marsden, his stepmother, dies.

 October: Exhibition at the Münchener Graphik-Verlag, Berlin, of 45 paintings and some drawings.

 December 11: Leaves for New York.

1916 March: Participates in "The Forum Exhibition of Modern American Painters."

April 4: Exhibition of German Officer paintings at 291.

July 13: Arrives in Provincetown, Massachusetts, for the summer.

December: Spends the winter in Bermuda with Charles Demuth.

1917 January: First essays and poems appear in print in *The New Republic* and *Seven Arts*.

April: Participates in the First Annual Exhibition of the Society of Independent Artists.

May: Leaves Bermuda for New York.

June: Arrives in Ogunquit, Maine, at Hamilton Easter Field's art colony.

1918 June 14: Arrives in Taos, New Mexico.

November 6: Moves to Santa Fe.

1919 February: Visits Carl Sprinchorn in California, returning to Santa Fe only in June.

November 19: Leaves New Mexico for New York.

1920 May 4: Appointed Secretary of Katherine Dreier's Société Anonyme.

June: Goes to Gloucester, Massachusetts, for the summer.

Fall: In New York. Publishes poems in *Poetry* and *The Little Review*.

1921 Spring: Publishes *Adventures in the Arts*.

May 17: Public auction at Anderson Galleries, New York, raises almost $4,000.

July: Arrives in Paris; reaches Berlin in late November.

1923 Spring: *Twenty-five Poems* published by Robert McAlmon in Paris.

July: Nude pastel studies.

Winter: Does an Italian tour, primarily Florence and Rome.

1924 February: Goes to New York to arrange bankers' annual stipend of $2,000.

July 25: Arrives in Paris.

1925 January: Participates in a group show of American artists at the Galerie Briant-Robert, Paris.

August: Moves to Vence, taking a year's lease on a house.

1926 October: Moves to Aix-en-Provence; in December settles in the Maison Maria, once a studio of Cezanne's.

1927 Spring: Travels to Paris, Berlin, and Hamburg.

December: Returns to Paris.

1928 January: Visits the United States, not returning to Paris until August 20.

1929 April: Stays again in the Maison Maria until late November.

1930 March 5: After a farewell tour of Europe, sails to New York.

Summer: Stays in Sugar Hill near Franconia, New Hampshire.

November: Returns to New York and is severely ill with bronchitis.

1931 March: Receives Guggenheim travel grant.

July: Arrives in Gloucester and begins Dogtown series.

December: Returns to New York.

1932 March: Arrives in Mexico City early in month.

April 26: Exhibition, "The Return of the Native," at the Downtown Gallery in New York.

April 27: Hart Crane commits suicide.

November: Included in the first Whitney Biennial.

1933 February: Exhibits the year's work at the Galería de la Escuela Central de Artes Plásticas, Mexico City.

April: Sails from Vera Cruz for Hamburg.

September: After a summer in Hamburg, goes to Garmisch-Partenkirchen in the Bavarian Alps. Begins his autobiography.

1934 February: Leaves Europe, never to return; for the rest of his life, New York is his regular winter base.

March 29: Employed by the WPA in the easel painting division for one month.

July: Returns to Gloucester for the summer.

1935 January 4: Has to destroy 100 paintings and drawings in storage.

February: Included in the "Abstract Painting in America" exhibition, at the Whitney Museum.

June: Makes second and last visit to Bermuda.

September: Goes to Blue Rocks, Nova Scotia, meeting the Mason family and moving in with them as a boarder in November. Returns to New York in December.

1936 January 29: Employed by the WPA until May 14.

July: Returns to Nova Scotia.

September 19: Donny and Alty Mason drown with their cousin Allan.

September: Included in the "New Horizons in American Art" exhibition, at the Museum of Modern Art.

December: Hartley returns to New York.

1937 April 20: Last exhibition with Stieglitz: Writes "On the Subject of Nativeness—A Tribute to Maine" for the catalogue.

June: Returns to Maine, first to Georgetown for the summer, and then to Portland.

1938 February: First solo exhibition with the Hudson Walker Gallery, New York.

Summer: To Vinalhaven and then to Boston in November. Begins "archaic portraits."

1939 February: New York City.

March: Exhibits first "archaic portraits" at Hudson Walker.

June: Portland.

September: Bangor.

October: Visits Mount Katahdin.

1940 January: Receives $300 prize for *End of Hurricane* in the Pennsylvania Academy annual exhibit.

March: Exhibits first Mount Katahdin paintings and more figural works at Hudson Walker.

August: Moves to Corea, Maine, and stays with the Youngs. *Androscoggin*, a book of poems, is published by Leon Tebbetts.

1941 January. Winters in Bangor, and then goes to New York. For the rest of his life moves between Corea and New York. *Sea Burial*, a book of poems, is published by Tebbetts.

October: Joint exhibition with Stuart Davis at the Cincinnati Art Museum.

December: Receives fourth prize of $2,000 for *Lobster Fishermen* in the "Artists for Victory" exhibition, at the Metropolitan Museum.

1942 November: First exhibition at Paul Rosenberg and Company, New York.

1943 September 2: Dies of heart problems, in Ellsworth, Maine.

Selected Bibliography

The two greatest repositories of Hartley documents are at Yale University and the Archives of American Art. Norma Berger, Hartley's niece and literary executor, gave his literary manuscripts and correspondence (with her), along with some clippings and memorabilia, to Yale Collection of American Literature, Beinecke Rare Book and Manuscript Library, Yale University. The literary papers have been microfilmed for the Archives of American Art. Elizabeth McCausland embarked on a catalogue raisonné and biography, and collected many letters and reminiscences, along with photographs and other materials. These have been deposited at the Archives of American Art and microfilmed. Both libraries also contain extensive correspondence with Hartley in other collections of papers.

Beinecke also houses Alfred Stieglitz's papers, and those of many other of Hartley's contemporaries; the Archives of American Art also contains relevant letters and reminiscences. Hartley wrote an autobiography, "Somehow a Past," which was never published and exists in several versions in Beinecke. His book *Adventures in the Arts* also contains autobiographical notes; his poetry and writing on the arts, contained in *The Collected Poems* and *On Art* respectively, are also rich sources for his opinions.

Quotations and facts left uncited have either been published (in part or whole) in the standard, recent monographs or may be found in the following locations:

Monographs

BARBARA HASKELL. *Marsden Hartley.* New York: Whitney Museum of American Art, 1980.

GAIL SCOTT. *Marsden Hartley.* New York: Abbeville, 1988.

TOWNSEND LUDINGTON. *Marsden Hartley: The Biography of an American Artist.* Boston: Little, Brown, 1992.

JEANNE HOKIN. *Pinnacles and Pyramids: The Art of Marsden Hartley.* Albuquerque: University of New Mexico, 1993.

These contain excellent bibliographies and exhibition lists.

Autobiographical References

"Somehow a Past." An unfinished autobiography existing in a typescript and several manuscript versions. Hartley Papers, Yale.

Hartley's Writings on the Arts

Adventures in the Arts: Informal Chapters on Painters, Vaudeville and Poets. New York: Boni & Liveright, 1921.

On Art. Edited and with an introduction by Gail R. Scott. New York: Horizon Press, 1982.

Hartley's Poems

The Collected Poems of Marsden Hartley, 1904–1943. Edited and with an introduction by Gail R. Scott. Santa Rosa, Calif.: Black Sparrow Press 1987.

Correspondents

Yale—Norma Berger, Frank Davison, Donald Greason, Mabel Dodge Luhan, Robert McAlmon, Carl Sprinchorn, Gertrude Stein, Alfred Stieglitz, Leon Tebbetts, Nina Waldeck.

Archives of American Art—Adelaide Kuntz, Elizabeth McCausland, Arnold Rönnebeck, Carl Sprinchorn, Helen Stein, Rebecca Strand, Richard Tweedy, Hudson Walker.

Additional Bibliography

GERALD FERGUSON. *Marsden Hartley and Nova Scotia.* Halifax, Nova Scotia: Mount Saint Vincent University Art Gallery, in association with The Press of the Nova Scotia College of Art and Design and the Art Gallery of Ontario, 1987.

GAIL LEVIN. "Marsden Hartley and Mysticism," *Arts Magazine* 60 (November 1985), pp. 16–21.

ELIZABETH McCAUSLAND. *Marsden Hartley.* Minneapolis: University of Minnesota, 1952.

JONATHAN WEINBERG. *Speaking for Vice: Homosexuality in the Art of Charles Demuth, Marsden Hartley, and the First American Avant-Garde.* New Haven and London: Yale University, 1993.

Photograph Credits

The photographs in this book have been supplied by the proprietary holders of the works and were made by their staff photographers with the exception of the following: p. 57: Michael J. Smith; p. 72: Courtesy M. Knoedler & Co.; p. 80 below: Helga Photo Studio; p. 86: © Sarah Wells 1983; p. 96: Art Resource, New York; p. 97: Geoffrey Clements; p. 105: James R. Dunlop; p. 125 right: Melville McLean

Index

Italic page numbers refer to illustrations.